Charles Rennie Mackintosh

Charles Rennie Mackintosh

Editor in chief:
Paco Asensio

Editor and original texts:
Sol Kliczkowski

Photographs:
© The Glasgow Picture Library, Eric Thorburn.

Photographs on pages 6 to 9 and drawings:
© Hunterian Art Gallery, University of Glasgow

English translation:
Michael Bunn

German translation:
Bettina Beck

French translation:
Clarise Plasteig

Italian translation:
Grazia Suffriti

Graphic Design/Layout:
Emma Termes Parera and Soti Mas-Bagà

Published worldwide by teNeues Publishing Group
(except Spain, Portugal and South-America):

www.teneues.com

Editorial project:

teNeues Book Division
Neuer Zollhof 1, 40221 Düsseldorf, Germany
Tel: 0049-(0)211-994597-0
Fax: 0049-(0)211-994597-40

© 2002 LOFT Publications
Domènech 7-9, 2o 2a
08012 Barcelona, Spain
Tel.: 0034 932 183 099
Fax: 0034 932 370 060
e-mail: loft@loftpublications.com
www.loftpublications.com

teNeues Publishing Company
16 West 22nd Street, New York, N.Y., 10010, USA
Tel.: 001-212-627-9090
Fax: 001-212-627-9511

teNeues Publishing UK Ltd.
Aldwych House, 71/91 Aldwych
London WC2B 4HN, UK
Tel.: 0044-1892-837-171
Fax: 0044-1892-837-272

Printed by:
Gráficas Anman. Sabadell, Spain.

September 2002

teNeues France S.A.R.L.
140, rue de la Croix Nivert
75015 Paris, France
Tel.: 0033-1-5576-6205
Fax: 0033-1-5576-6419

We would like to thank for the collaboration of Lis y Eric Thorburn, of The Glasgow Picture Library; Lynda Clark, of Hunterian Museum and Art Gallery; Anne Ellis, of The National Trust for Scotland, and Dorothy McKay, of "House for an Art Lover".

Die Deutsche Bibliothek – CIP-Einheitsaufnahme
Ein Titeldatensatz für diese Publikation ist bei der Deutschen Bibliothek erhältlich.

ISBN: 3-8238-5543-3

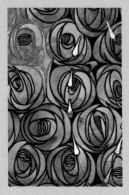

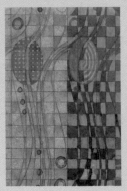

Stylised tulips on checkerboard pattern,
textile design (1915–1923)

Stilisierte Tulpen auf Schachbrettmuster,
Textildesign (1915–1923)

Tulipes stylisées sur damier, dessin sur
tissu (1915–1923)

Tulipani stilizzati su scacchiera, disegno
tessile (1915–1923)

Rose and tear, textile design (1915–1923)
Rose mit Träne, Textildesign (1915–1923)
Rose et larme, dessin sur tissu (1915–1923)
Rosa e lacrima, disegno tessile (1915–1923)

Most of Charles Rennie Mackintosh's architectural projects were based in Glasgow, a city that did not begin to be recognized as a focus for the arts until 1890, and where architecture was turning away from the neo-classical austerity of 18th-century ideas to return to an imitation of northern Renaissance designs featuring tall towers and high pediments. At the turn of the century, the French, German and Italian avant-garde influence reached Glasgow – via England – full of freshness and energy, and which would give form to a characteristic style. Works by new artists began to appear in European galleries and museums, to the great interest of students at the Glasgow School of Art and its new director, Francis H. Newbery, who later became one of Mackintosh's most loyal supporters.

In addition, with its use of traditional crafts and design, the Arts & Crafts movement offered architects a new medium for creative exploration. This movement had an enormous influence on young designers; Mackintosh derived from it a tendency towards abstraction, a reinterpretation of nature and the use of curved and protracted lines. He became, in fact, one of the few designers of his time daring enough to risk innovation, along with Sullivan in the United States, Horta in Brussels, and Mackmurdo, Voysey and Baillie Scott in England.

Mackintosh absorbed ideas from many different influences, which are visible in his works: for example, interior decorations such as at the Willow Tea Rooms are inspired by both Celtic and Art Nouveau designs. There is also the asymmetrical doorway in the façade of the Glasgow School of Art, which demonstrates his unique way of creating an undulating space, though the building's polygonal tower takes its inspiration from ancient Scottish architecture. Mackintosh also applied his multi-purpose talents to architectural structures – the round vaulting at Queen's Cross Church, for example, demonstrates his skill when working with wood. In all of his designs, there is a personal touch combined with the heritage of the Scottish tradition, as can be seen at Windyhill and the Hill House. The graceful curves that he borrows from Art Nouveau styles alternate with the austere lines of the incipient Modern movement, as well as his use of dark tones and pastel colours. His inventiveness is visible in his designs for windows, stairways, pillars, façades with projections, as well as the decorative features that have no practical utility and the spatial arrangement of all of his designs. Mackintosh worked personally on all of the decorative features, to the extent that he even designed the cutlery for the tea rooms.

Another facet of this architect was his great talent as a painter. As well as creating patterned fabrics using traditional methods, he also made fabrics which were manufactured on an industrial scale by two large English firms. Although he had been painting in watercolours since his youth, it was not until 1913 that he began to paint professionally, in the absence of any other commissions at the time. These paintings feature impetuous lines and a kind of cubism, and in them we can recognize the eye of an artist who is sensitive to the articulation of volumes.

A look through his main architectural works is sufficient to reveal his talent and genius; these buildings have served as an inspiration for 20th century architecture, and their influence has been far-reaching.

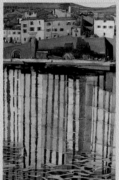

The street of the sun (1926)
Die Straße der Sonne (1926)
La rue du soleil (1926)
La strada del sole (1926)

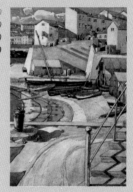

The Little Bay (1927)
Die kleine Bucht (1927)
La petite baie (1927)
La piccola baia (1927)

Mackintosh vollbrachte den Großteil seiner Arbeit als Architekt in Glasgow. Bis 1890 war diese Stadt nicht als Kunstzentrum bekannt. Sie hatte in ihrer Bauweise die neoklassische Strenge vom Anfang des 18. Jahrhunderts hinter sich gelassen und war zu einer Nachempfindung der nordischen Renaissance mit großen Schornsteinen und hohen Giebeln zurückgekehrt. Am Ende des Jahrhunderts gelangte der avantgardistische Einfluss aus Frankreich, Deutschland und Italien voller Frische und Kraft über England nach Glasgow und nahm dort ganz eigene Formen an. Die Werke der neuen Künstler begannen in europäischen Galerien und Museen zu zirkulieren und erweckten dort großes Interesse unter den Schülern der Kunstschule von Glasgow und bei deren neuem Direktor Francis H. Newbery, von dem Mackintosh große Unterstützung erhalten sollte.

Auf der anderen Seite ist die Arts & Crafts-Bewegung zu erwähnen, deren Beitrag in Bezug auf Handwerk und Design in einem neuen Forschungsweg bestand, den bald auch Architekten einschlagen sollten. Die Bewegung beeinflusste die jungen Designer ganz enorm und Mackintosh erbte von ihr die Tendenz zum Abstrakten, die Neuinterpretierung der Natur oder auch die gebogene und längliche Linienführung. Und so wurde er zu einem der wenigen, die zu jenem Zeitpunkt den Mut zu Erneuerungen hatten, wie es bei Sullivan in den Vereinigten Staaten, Horta in Brüssel und Mackmurdo, Voysey und Baillie Scott in England der Fall war.

Die Einflüsse, denen Mackintosh unterliegt, sind äußerst vielfältig und daher ebenso auch die Ergebnisse seines Schaffens. Bei Dekorationen wie dem Teesalon Willow kann man keltische Inspiration und Einflüsse des Art Nouveau spüren. Die Asymmetrie des Portals der Kunstschule von Glasgow ist ein Beispiel für die eigentümliche Art Mackintoshs, dem Raum wellenartige Formen zu verleihen,

obwohl andererseits das vieleckige Türmchen von der antiken schottischen Bauweise inspiriert ist. Die vielseitige Begabung Mackintoshs ist bei allen seinen Bauwerken unverkennbar. So tritt zum Beispiel im Falle des Tonnengewölbes der Queen's Cross-Kirche seine Art der Holzbearbeitung deutlich zutage. Alle seine Entwürfe kombinieren seine persönliche Linienführung mit dem Erbe der schottischen Tradition, wie bei Windyhill und dem Hill-Haus klar festzustellen ist. Die vom Art Nouveau beigesteuerte Anmut der Kurven steht wie die dunklen und pastellfarbenen Töne im Wechsel mit den strengen Linien des einsetzenden Modernismus. Mackintoshs Erfindungsreichtum spiegelt sich in Fenstern, Treppenhäusern, Säulen, Fassaden mit Vorsprüngen, schmückenden Elementen ohne praktischen Nutzen und der räumlichen Anordnung bei allen seinen Projekten wider. Er kümmerte sich um sämtliche dekorative Details und entwarf sogar das Besteck für die Teesalons.

Eine andere Seite dieses Baumeisters war die Malerei, in der seine außerordentliche Begabung zum Ausdruck kommt. Er bedruckte Stoffe, beschäftigte sich aber auch mit den industriell hergestellten Stoffen zweier großer englischer Unternehmen. Obwohl er von jung an mit Aquarellen arbeitete, widmete er sich dieser Technik auf professionelle Weise erst um 1913, als es ihm an andersartigen Aufträgen mangelte. Diese Malereien zeichnen sich durch ungestüme Linien und einen gewissen Kubismus aus und der Blick des Künstlers und seine Sensibilität für das Zusammenspiel der verschiedenen Einheiten sind klar zu erkennen.

Es reicht ein Gang durch die bedeutendsten Bauwerke Mackintoshs, um seine Genialität und große Begabung zu spüren, die die Architektur des 20. Jahrhunderts inspirierten und ihre Richtung unstrittig vorzeichneten.

Mackintosh réalisa la plus part de son travail architectural à Glasgow, ville qui ne se fit connaître comme pôle artistique avant 1890, mais dont l'architecture avait abandonné l'austérité néoclassique du début du 18ème siècle pour revenir à une imitation de la Renaissance nordique, aux grandes tours et hauts frontons. A la fin du siècle, l'influence avant-gardiste de France, d'Allemagne, et d'Italie arrive à Glasgow passant par une Angleterre pleine de fraîcheur et de vigueur, donnant naissance à un caractère propre. Les œuvres de nouveaux artistes commencent à circuler à travers les galeries et les musées européens et provoquent un grand intérêt parmi les élèves de l'Ecole d'Art de Glasgow et son nouveau directeur, Francis H. Newbery, qui soutiendra beaucoup Mackintosh.

D'un autre côté, le mouvement arts & crafts apporte, avec l'artisanat et le design, une nouvelle voix d'exploration à laquelle s'unissent aussi des architectes. Le mouvement influença énormément les jeunes dessinateurs ; Mackintosh en hérite sa tendance à l'abstraction, sa ré-interprétation de la nature ou encore ses lignes courbes et allongées. Il devient ainsi l'un des rares qui, à ce moment-là, osent innover, comme le font Sullivan aux Etats-Unis, Horta à Bruxelles, et Mackmurdo, Voysey et Baillie Scott en Angleterre.

De même que ses influences, les résultats de Mackintosh sont multiples. Dans ses décorations, celle du salon de thé Willow, on peut capter l'inspiration celtique, mêlée à l'art nouveau. L'asymétrie du porche de la façade de l'Ecole d'Art de Glasgow montre sa façon particulière de faire onduler l'espace, alors que la petite tour polygonale trouve son inspiration dans l'architecture écossaise ancienne. Mackintosh applique la polyvalence de son art à travers ses œuvres architecturales ; par exemple, dans la voûte en plein cintre de l'église Queen's Cross, où l'on peut apprécier sa manière de travailler le bois. Dans tous ses projets, son style personnel est mêlé à un héritage de la tradition écossaise, que l'on retrouve dans Windyhill et dans la maison Hill. Le charme des courbes que peut apporter l'art nouveau alterne avec l'austérité des lignes du Mouvement Moderne, alors naissant, de même manière que les tonalités obscures et les couleurs pastelles. Son originalité transparaît dans les fenêtres, les escaliers, les piliers, les façades avec reliefs, les éléments décoratifs sans utilité pratique, ainsi que dans la distribution spatiale de tous ses projets. Mackintosh se souciait des moindres détails décoratifs, allant jusqu'à dessiner les couverts des salons de thé. La peinture fut l'autre domaine où cet architecte exerça ses talents. Il imprima des tissus de manière artisanale, mais s'occupa aussi de tissus fabriqués à échelle industrielle pour deux grandes firmes anglaises. Bien qu'il travaille l'aquarelle depuis sa jeunesse, ce n'est que vers 1913 qu'il s'y consacre professionnellement, faute d'autre genre de commande. Dans ses peintures on perçoit des lignes impétueuses ainsi qu'un certain cubisme, et on y reconnaît le regard de l'artiste sensible à l'assemblage des volumes.

Il suffit de parcourir ses principales œuvres architecturales pour sentir son originalité et son talent, qui ont inspiré et marqué de manière indiscutable l'évolution de l'architecture du XXème siècle.

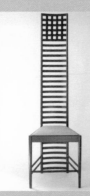

Ladder-back chair, at the Hill House
Stuhl Ladder Back, im Hill-Haus
Chaise Ladder Back, dans la Maison Hill
Sedia Ladder Back, nella Casa Hill

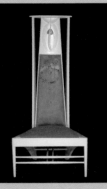

Chair for the Turin International Art Exhibition (1902)

Stuhl für die Internationale Kunstausstellung in Turin (1902)

Chaise pour l'Exposition Internationale d'Art de Turin (1902)

Sedia per l'Esposizione Internazionale d'Arte di Torino (1902)

Mackintosh esercitò la maggior parte della propria attività architettonica a Glasgow, una città che cominciò ad essere conosciuta come centro artistico solo a partire dal 1890, e la cui architettura aveva abbandonato l'austerità neoclassica degli inizi del XVIII° secolo per tornare all'imitazione del Rinascimento nordico, con grandi torrioni ed alti frontoni. Alla fine del secolo, l'influenza avanguardista di Francia, Germania ed Italia giunge a Glasgow attraverso l'Inghilterra ricca di freschezza e vigore, dando origine ad un carattere proprio. Le opere dei nuovi artisti cominciano a circolare in gallerie e musei europei e risvegliano un grande interesse sia tra gli alunni della Scuola d'Arte di Glasgow che sul suo nuovo direttore, Francis H. Newbery, che appoggerà fortemente Mackintosh.

D'altro canto il movimento arts & crafts apporta, attraverso l'artigianato ed il design, una nuova via d'esplorazione alla quale si uniranno anche alcuni architetti. Il movimento influenzò enormemente i giovani progettisti; Mackintosh ne eredita la tendenza all'astrazione, alla reinterpretazione della natura o delle linee curve ed allungate. Ed in questo modo si converte in uno dei pochi che in quel momento osano innovare l'architettura, come lo fanno Sullivan negli Stati Uniti, Horta a Bruxell, e Mackmurdo, Voysey e Baillie Scott in Inghilterra.

Le influenze che riceve Mackintosh sono molteplici e la stessa cosa accade ai risultati. Nell'arredamento della sala da tè Willow si percepisce l'ispirazione celtica e dell'art nouveau. L'asimmetria del vestibolo della facciata della Scuola d'Arte di Glasgow, mostra il suo modo particolare di incurvare lo spazio, anche se la torretta poligonale si ispira all'antica architettura scozzese. Mackintosh applica la polivalenza del proprio talento alle sue opere architettoniche; ad esempio nella volta a tutto sesto della chiesa di Queen's Cross si apprezza il suo modo di lavorare il legno. In tutti i suoi progetti si compongono il tratto personale e l'eredità della tradizione scozzese, come si può osservare a Windyhill e nella casa Hill. La grazia delle curve che può apportare l'art nouveau si alterna all'austerità delle linee del nascente Movimento Moderno, così come accade tra le tonalità scure ed i colori pastello. Il suo talento si riflette in finestre, scale, pilastri e facciate con sporgenze, con elementi decorativi senza utilità pratica, e nella disposizione spaziale di tutti i suoi progetti. Mackintosh si occupava di tutti i particolari decorativi, progettava perfino le posate delle sale da tè.

Un altro aspetto dove quest'architetto manifestò il suo grande ingegno fu la pittura. Stampò artigianalmente dei tessuti, ma si occupò anche di stoffe prodotte su scala industriale per due grandi marche inglesi. Anche se fin da giovane dipingeva ad acquerello non vi ci si dedicò professionalmente fino al 1913, in mancanza di altri tipi di incarichi. In questi dipinti si percepiscono linee impetuose ed un certo cubismo, e vi si riconosce lo sguardo dell'artista sensibile all'articolazione dei volumi.

E' sufficiente scorrere le sue principali opere architettoniche per intuire la sua genialità ed il suo talento, che hanno ispirato l'architettura del XX° secolo e che ne hanno marcato indiscutibilmente la rotta.

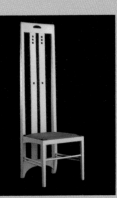

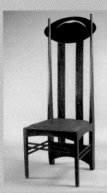

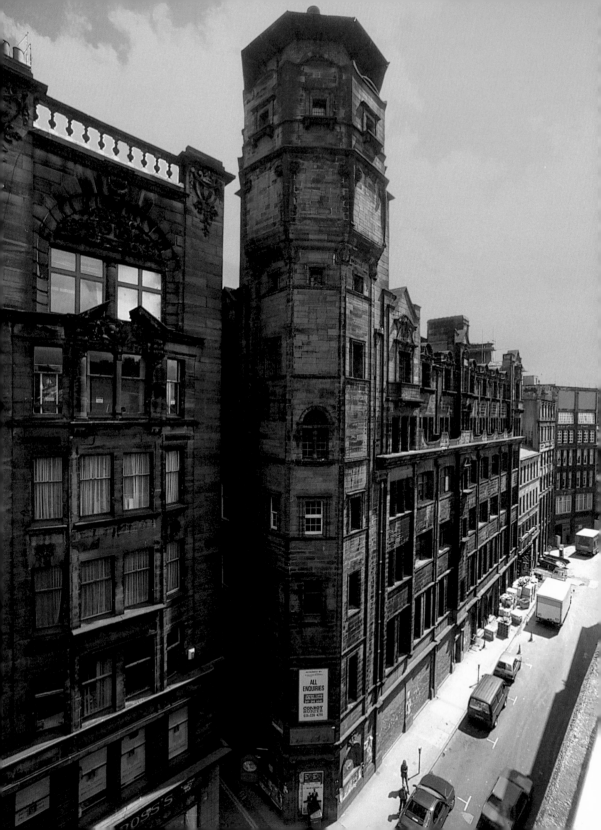

Glasgow Herald Building

Mitchell Lane, Glasgow, UK
1894

This construction, which was built for the "Glasgow Herald" between 1893 and 1895, stands on a corner and features a tower which at that time housed a water tank with a capacity of 36,000 litres. Apart from the newspaper's offices, the building now contains a number of shops and storerooms. The project was commissioned to the agency Honeyman & Keppie, in which a young draftsman called Mackintosh was working. It is difficult to discern how much of a hand Mackintosh had in the building's design, but his influence is particularly visible in the tower, the asymmetrical rhythm of the windows on the façade and in the organicistic-style decoration.The bell tower and its flat dome combine harmoniously with the adjacent architecture, providing a formal originality while maintaining a distinguished style. The tower was conceived as a fire prevention system, and included safety measures such as fireproof materials and a hydro-pneumatic lift. The construction as a whole has great architectural quality, and shows important contributions by Mackintosh; this project forms part of his legacy, being one of his first professional works.

Dieses zwischen 1893 und 1895 auf Kosten des „Glasgow Herald" errichtete Gebäude befindet sich an einer Ecke und hebt sich durch den Turm hervor, der zu jener Zeit einen 36.000 Liter fassenden Wasserspeicher enthielt. Heutzutage beherbergt es außer den Büros der Zeitung verschiedene Geschäfte und Lager. Das Projekt wurde bei dem Büro Honeyman & Keppie in Auftrag gegeben, bei dem der junge Mackintosh als Zeichner arbeitete. Es ist schwierig genau zu sagen, worin sein Anteil bestand. Sein Einfluss ist jedoch besonders bei dem Turm spürbar, dessen Fenster die Fassade in asymmetrischem Rhythmus überziehen, und ebenso an der von organischen Formen inspirierten Dekoration. Der Glockenturm und seine flache Kuppel fügen sich harmonisch in die Architektur der angrenzenden Gebäude ein. Ihr Beitrag besteht in der Originalität der Formen, wobei sie aber gleichzeitig den distinguierten Stil bewahren. Der Turm war als Brandschutzsystem konzipiert und bestand daher aus feuerbeständigen Materialen und einem hydropneumatischen Aufzug als Sicherheitsmaßnahmen. Der Komplex ist von großer architektonischer Qualität und lässt die entscheidende Mitwirkung Mackintoshs durchscheinen, der uns mit diesem Projekt eine seiner ersten professionellen Zeichnungen hinterlassen hat.

Cette construction finalisée entre 1893 et 1895 pour le compte du « Glasgow Herald », se situe à un angle de rue et se distingue par la tour qui renfermait, alors, un réservoir d'eau d'une capacité de 36.000 litres. Aujourd'hui elle abrite, en plus des locaux du journal, plusieurs boutiques et entrepôts. Le projet fut commandé à l'agence Honeyman & Keppie, dans laquelle le jeune Mackintosh travaillait comme dessinateur. S'il est difficile de dire avec précision qu'elle fut sa contribution à cette œuvre, on perçoit cependant son influence, particulièrement dans la tour, dans le rythme asymétrique des fenêtres qui parsèment la façade, et dans la décoration à tendance organiciste. Le clocher et sa coupole plane s'intègrent harmonieusement à l'architecture contiguë, apportant de l'originalité aux formes, tout en maintenant l'élégance de son style. La tour, conçue comme un système anti-incendie, disposait de matériaux ignifugés et d'un ascenseur hydropneumatique comme moyens de sécurité. L'ensemble est d'une grande qualité architecturale, d'où émerge l'intervention décisive de Mackintosh, lequel nous a légué avec ce projet un de ses premiers dessins professionnels.

Questa costruzione, che fu portata a termine tra il 1893 e il 1895 per conto del "Glasgow Herald", è situata in un angolo e risalta per la torre che, a quell'epoca, conteneva un serbatoio d'acqua con una capacità di 36.000 litri. Attualmente ospita, oltre agli uffici del giornale, diversi negozi e magazzini. Il progetto fu incaricato all'agenzia Honeyman & Keppie, dove lavorava come disegnatore un giovane chiamato Mackintosh. E difficile stabilire quale fu il suo apporto, ma la sua influenza si percepisce specialmente nella torre, nel ritmo asimmetrico delle finestre che percorrono la facciata e nella decorazione di tendenza organicista. Il campanile e la sua cupola piana si integrano armoniosamente nell'architettura circostante, apportando originalità alle forme, pur mantenendo il proprio stile raffinato. La torre fu concepita come sistema contro gli incendi, cosicché si utilizzarono, come misure di sicurezza, materiali ignifughi ed un ascensore idropneumatico. Il complesso esprime un'elevata qualità architettonica e rivela l'intervento decisivo di Mackintosh, che ci ha trasmesso con questo progetto uno dei suoi primi disegni professionali.

Structural Section
Schnitt des Aufbaus
Section de la structure
Sezione della Struttura 0 1 2

Sketch of the façade **Entwurf der Fassade**
Esquisse de la façade **Schizzo della facciata**

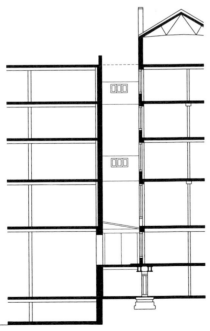

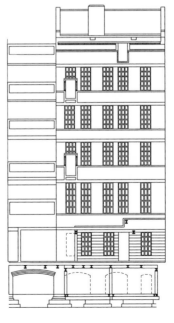

Sections **Schnitte**

Sections **Sezione**

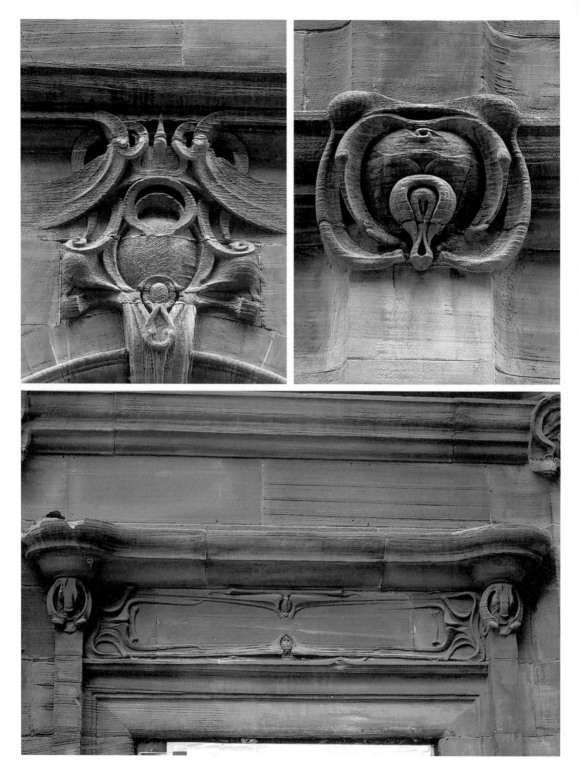

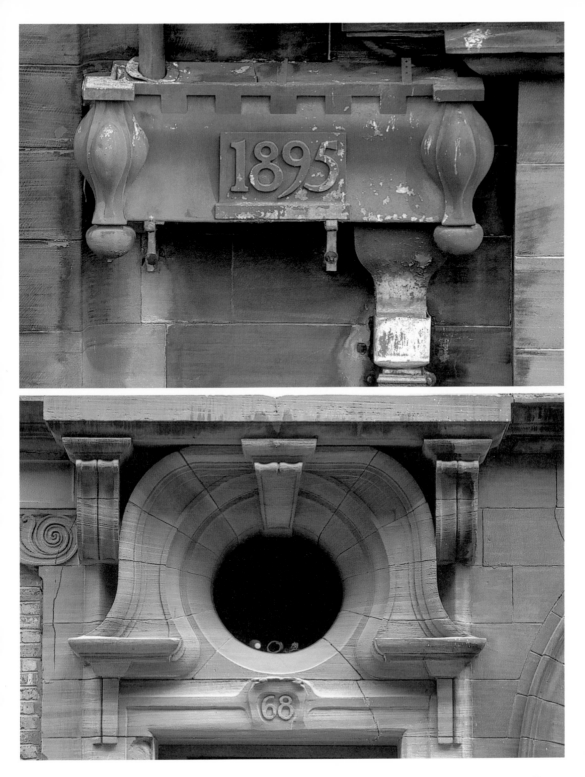

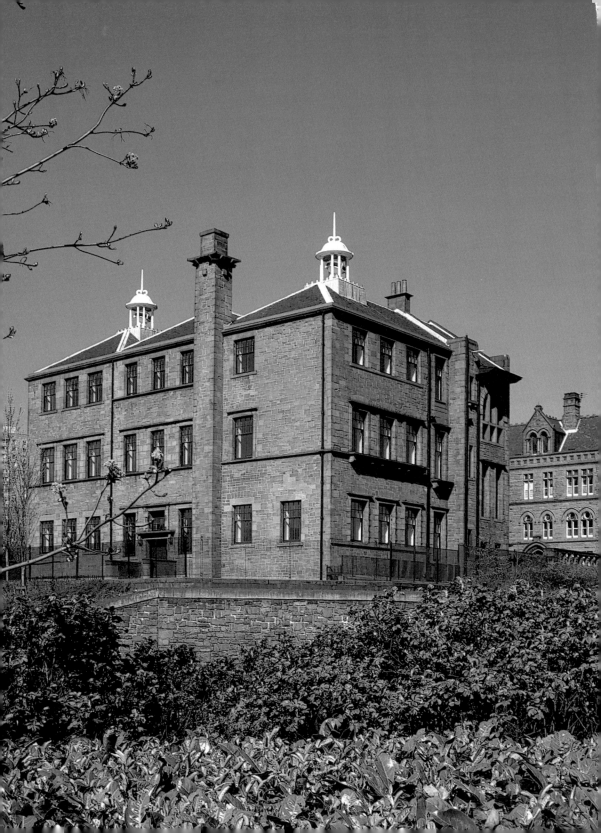

Martyr's Public School

11 Parson Street, Glasgow, UK
1895

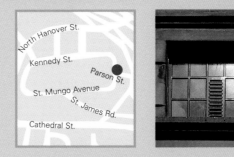

When the City Schools Committee commissioned the design of a school large enough for 1,000 students, it established some very strict conditions: the building plot was quite small, and so was the budget. But in spite of these obstacles, Mackintosh managed to express all the originality of his own unique style in this building. While the ground plan shows the typical distribution for this type of institution at that time, the architect's personality is reflected by the Art Nouveau features at the entrances and the wooden eaves on the exterior façade. The roof is surprising in terms of structure, as it possesses a certain Oriental style. By combining different elements, the architect succeeded in creating a visual whole whose charm lies in features such as the high windows, the decoration of the main entrance and the exposed beams on the roof structure. The building's design was softened by the inclusion of three white-painted, octagonal, ogival volumes which were mounted on the roof and which serve to ventilate the interior spaces. When this building was subsequently restored, it was discovered that certain features which appeared to be structural were no more than decorative details, while a number of decorations were found to conceal structural supports.

Das Programm dieser Schule für etwa tausend Schüler, mit dem der städtische Schulausschuss Mackintosh beauftragte, war sehr streng: ein kleiner Bauplatz und ein begrenztes Budget. Aber nichtsdestotrotz gelang es ihm, bei dieser Schule seinen originellen Stil zu verwirklichen. Der Grundriss entspricht der damals für diese Art von Einrichtungen eigenen Aufteilung: Die Hand des Architekten ist dagegen an den Art Nouveau-Elementen an den Eingängen und den Holztraufen der Fassade zu erkennen. Die überraschende Struktur des Daches sticht durch einen gewissen orientalischen Stil hervor. Durch die Kombination unterschiedlicher Elemente schafft der Architekt einen visuellen Komplex, dessen Reiz in Details wie den hohen Fenstern, der Dekoration des Haupteinganges und der Dachstruktur aus sichtbaren Balken liegt. Dem Gebäude wird durch drei weiß gestrichene achteckige, spitzovale Volumen, die auf das Dach gesetzt wurden und deren Aufgabe die Belüftung des Innenraumes war, die Schwere genommen. Während einer später durchgeführten Renovierung konnte festgestellt werden, dass bestimmte, dem Anschein nach tragende Elemente lediglich schmückende Details waren, hingegen verbargen sich unter einigen Ornamenten Stützen der Struktur.

Quand le comité scolaire de la ville commanda ce programme d'une école d'une capacité de mille élèves, environ, il fut très strict quant aux conditions fixées : un terrain réduit et un budget limité. Malgré cela, l'architecte réussit à rendre au travers de cette école l'originalité de son style personnel. Le plan correspond à la distribution normale de l'époque pour ce type d'institutions. La marque de l'architecte est donc suggérée par les éléments art nouveau situés aux entrées et par les avancées de bois de la façade. La surprenante structure du plafond se démarque du reste en apportant un certain style oriental. Grâce à l'assemblage d'éléments différents, l'architecte réalise un ensemble visuel dont le charme réside dans des détails tels que la hauteur des fenêtres, la décoration de l'entrée principale, et la structure en poutres apparentes de la toiture. Le bâtiment est allégé par la présence de trois volumes de forme octogonale et ogivale, peints en blanc, et placés sur le toit et dont la tâche est de ventiler les espaces intérieurs. Plus tard, lorsque s'achevèrent les travaux de restauration, on put constater que certains éléments ; faisant a priori partie de la structure, n'étaient pas plus que des détails décoratifs, et que, à l'inverse, certains ornements dissimulaient des étais de la structure.

Il progetto della scuola per circa mille alunni che il comitato scolastico della città incaricò a Mackintosh fu molto rigido: un piccolo lotto ed un preventivo limitato. Anche così, l'architetto riuscì a modellare in questa scuola l'originalità del suo stile caratteristico. La pianta corrisponde alla distribuzione, tipica dell'epoca, di questo tipo di edifici pubblici; pertanto l'impronta dell'architetto viene suggerita dagli elementi art nouveau situati all'entrata e dagli aggetti in legno della facciata. Emerge la sorprendente struttura del tetto, che conferisce un certo stile orientaleggiante. Attraverso la combinazione di differenti elementi, l'architetto ottiene un insieme visivo il cui incanto risiede nei particolari come le alte finestre, la decorazione dell'entrata principale e la struttura con travi a vista del tetto. L'edificio fu alleggerito attraverso tre volumi dipinti di bianco, situati sul tetto, a forma ottogonale ed ogivale, il cui scopo era quello di ventilare l'interno. Quando in seguito fu portato a termine un restauro, si constatò che certi elementi che sembravano strutturali non erano altro che particolari decorativi e che, a loro volta, alcuni ornamenti nascondevano appoggi della struttura.

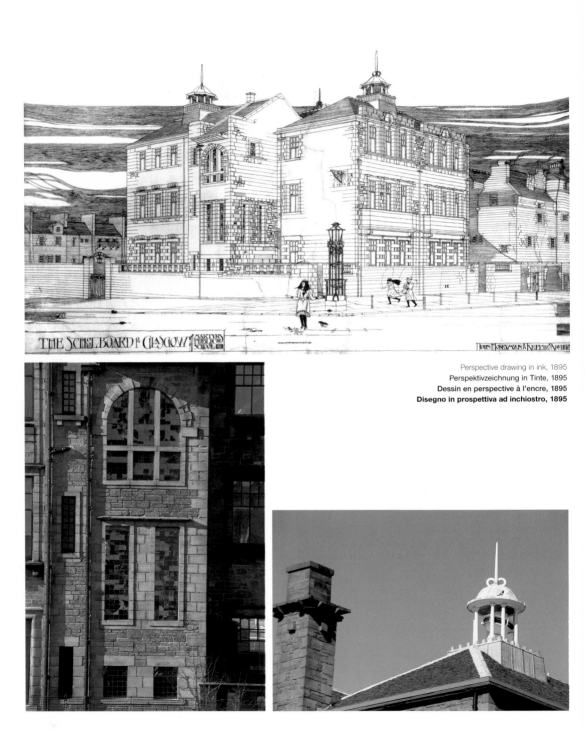

Perspective drawing in ink, 1895
Perspektivzeichnung in Tinte, 1895
Dessin en perspective à l'encre, 1895
Disegno in prospettiva ad inchiostro, 1895

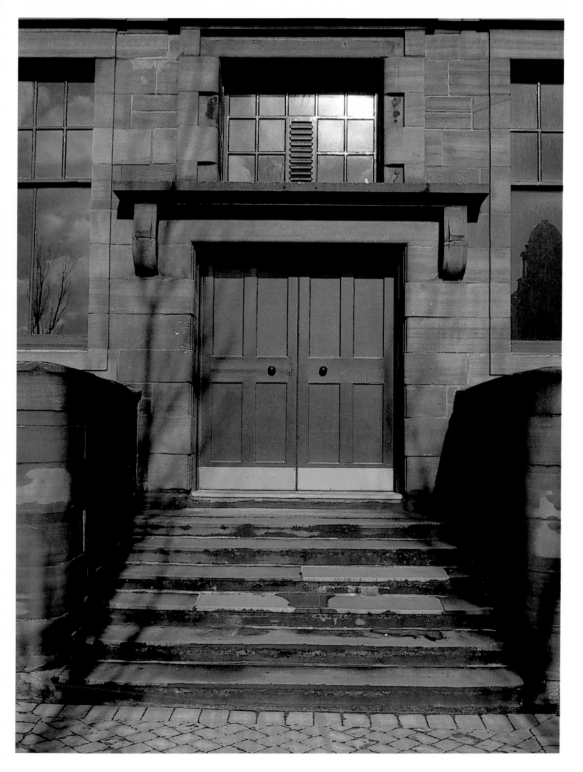

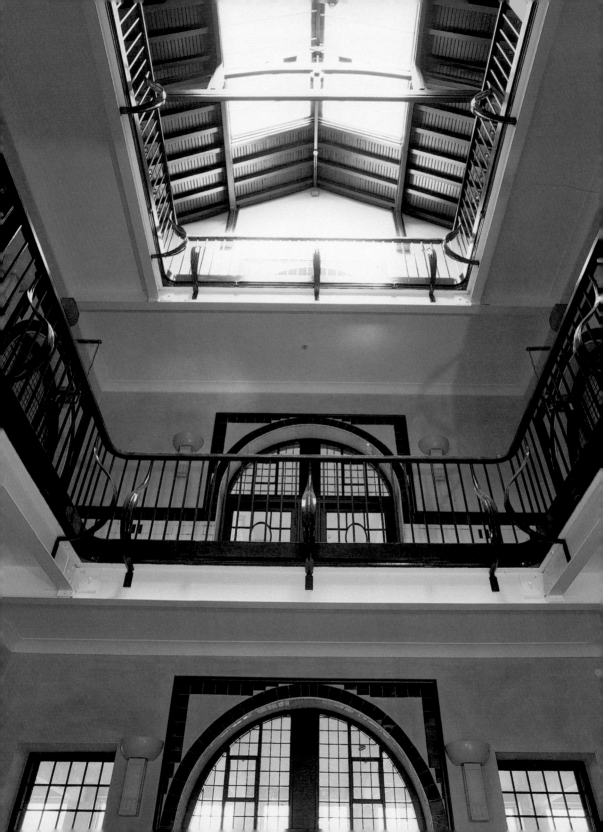

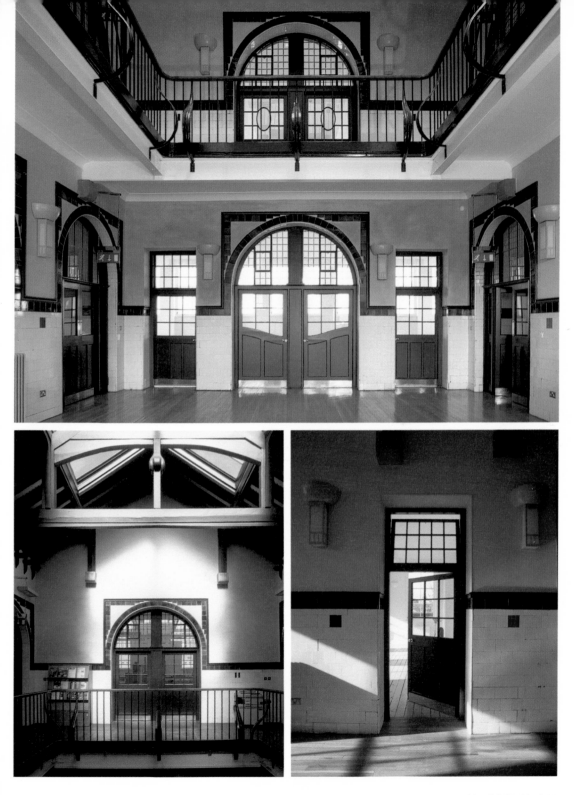

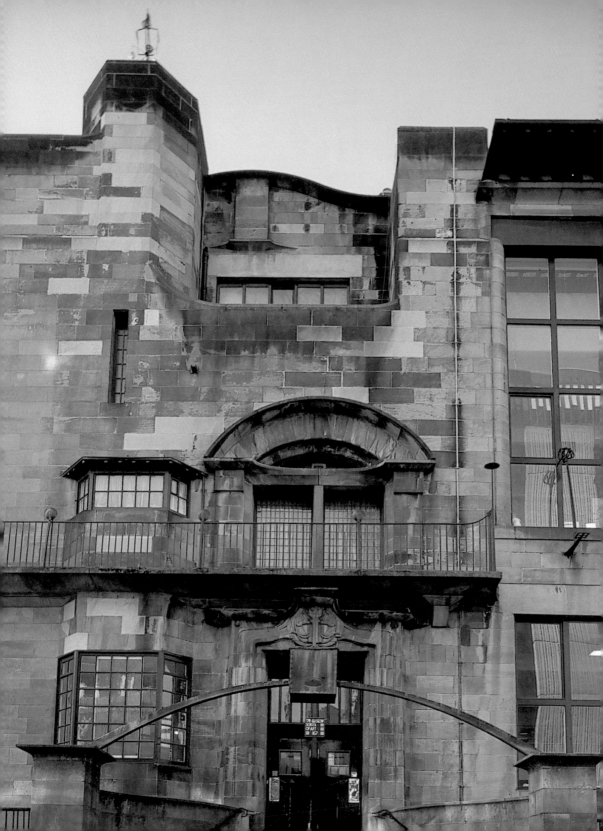

Glasgow School of Art

167 Renfrew Street, Glasgow, UK
1897–1909

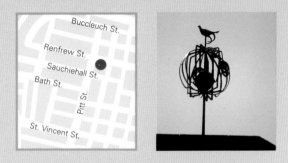

In 1895, Francis H. Newbery, the director of the Glasgow School of Art, decided that a new building was necessary, as a result of increased student numbers. Twelve of the city's architectural studios offered designs for a tender which was given a very limited budget. It was the firm Honeyman & Keppie, in which Mackintosh was working, that won the tender. Mackintosh's plans were the object of great controversy, as many people considered that his design was an exercise in the Art Nouveau style favoured by Newbery. The plans featured an asymmetrical entrance, around which the north façade was designed. Later, in 1907, the west façade was added, a section which demonstrates the evolution of the architect and his familiarity with applied arts and contemporary European architecture. The interior of the library, which has two levels, is surprisingly modern: it contains a gallery supported by dark wood columns, while the reading room, which is also furnished with wood, is illuminated by tall windows. Another striking feature is the wood and glass gallery that joins the two wings of the school. This great project was Mackintosh's masterpiece, and its innovative influence has brought generations of architects on a pilgrimage to Glasgow to see the building.

1895 bewegte die Notwendigkeit, eine wachsende Anzahl von Studenten aufzunehmen, Francis H. Newbery, den Direktor der Kunstschule von Glasgow, dazu, über ein neues Gebäude nachzudenken. Zwölf Architekturbüros der Stadt bewarben sich auf die Ausschreibung hin. Der Gewinner war die Firma Honeyman & Keppie, bei der Mackintosh arbeitete. Seine Zeichnungen waren Gegenstand großer Kontroversen, da viele der Ansicht waren, dass es sich bei ihnen um eine von Newbery begünstigte Übung im Stile des Art Nouveau handelte. Der Entwurf sah einen asymmetrischen Eingang vor, um den herum die nördliche Fassade entwickelt wurde. Später wurde durch die Bauarbeiten von 1907 eine westliche Fassade hinzugefügt, die die Entwicklung des Architekten und seine Vertrautheit mit der Kunst zeigten. Das Innere der auf zwei Ebenen angeordneten Bibliothek ist überraschend modern: Es beherbergt eine Galerie, die von Säulen aus dunklem Holz getragen wird, und den Lesesaal, der sein Licht durch die hohen Fenster erhält. Hervorzuheben ist der Steg aus Glas und Holz, der die beiden Flügel der Schule verbindet. Dieses große Projekt ist eines von Mackintoshs Meisterwerken. Aufgrund seines innovativen Einflusses werden ganz sicher noch viele Generationen von Architekten Pilgerfahrten zu ihm unternehmen.

En 1895, la nécessité d'accueillir un nombre d'élèves croissant, amena Francis H. Newbery, directeur de l'Ecole d'Art de Glasgow, à projeter la construction d'un nouveau bâtiment. Douze études d'architectes de la ville participèrent à un concours que gagna l'agence Honeyman & Keppie, où travaillait Mackintosh. Les plans de Mackintosh furent l'objet de grandes controverses, en effet beaucoup considérèrent qu'il s'agissait d'un exercice de style art nouveau, favorisé par Newbery. Le dessin présentait une entrée asymétrique autour de laquelle se projetait la façade nord ; plus tard, les travaux de 1907 proportionnèrent la façade ouest, qui montre l'évolution de l'architecte et sa familiarité avec les arts. L'intérieur de la bibliothèque, sur deux niveaux, est étonnement moderne: Elle abrite une galerie supportée par des colonnes de bois sombre et la salle de lecture perçoit la lumière grâce à de très hautes fenêtres. Il faut souligner la passerelle de verre et de bois qui relie les deux ailes de l'école. Ce grand projet constitue le chef d'œuvre de Mackintosh et son influence innovatrice explique le pèlerinage de générations d'architectes.

Nel 1895, la necessità di accogliere un numero crescente di alunni portò Francis H. Newbery, direttore della Scuola d'Arte di Glasgow, a prospettare la costruzione di un nuovo edificio. Dodici studi d'architettura della città parteciparono ad un concorso che vinse la società Honeyman & Keppie, dove lavorava Mackintosh. I piani di Mackintosh furono oggetto di grandi controversie, perché molti considerarono che si trattava di un'esercitazione stile art nouveau agevolata da Newbery. Il progetto era costituito da un'entrata asimmetrica attorno alla quale si protendeva la facciata nord; in seguito, le opere del 1907 aggiunsero una facciata ovest che mostra l'evoluzione dell'architetto e la sua familiarità con l'arte. L'interno della biblioteca, a due livelli, è sorprendentemente moderno: accoglie una galleria sostenuta da colonne in legno scuro e la sala di lettura, che ottiene luce dalle alte finestre. Va sottolineata la passerella in legno e vetro che unisce le due ali della scuola. Questo grande progetto costituisce il capolavoro di Mackintosh e la sua innovativa influenza garantisce il "pellegrinaggio" di generazioni di architetti.

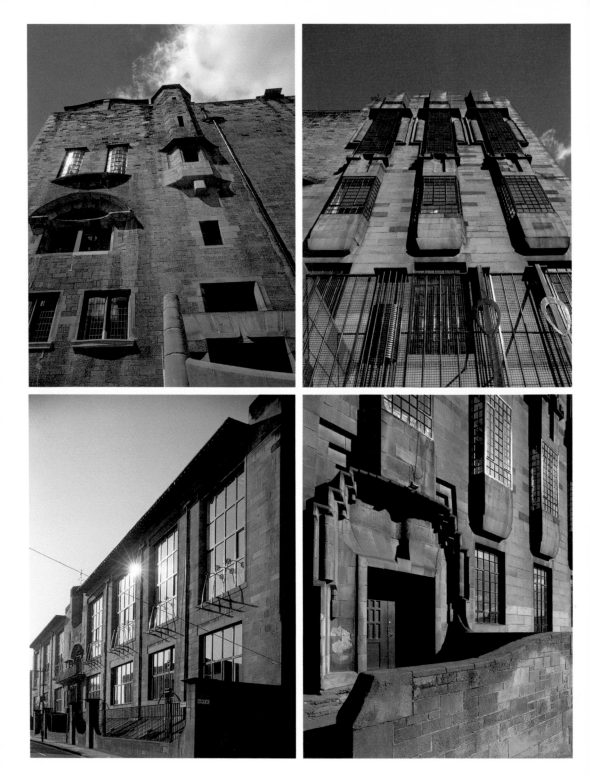

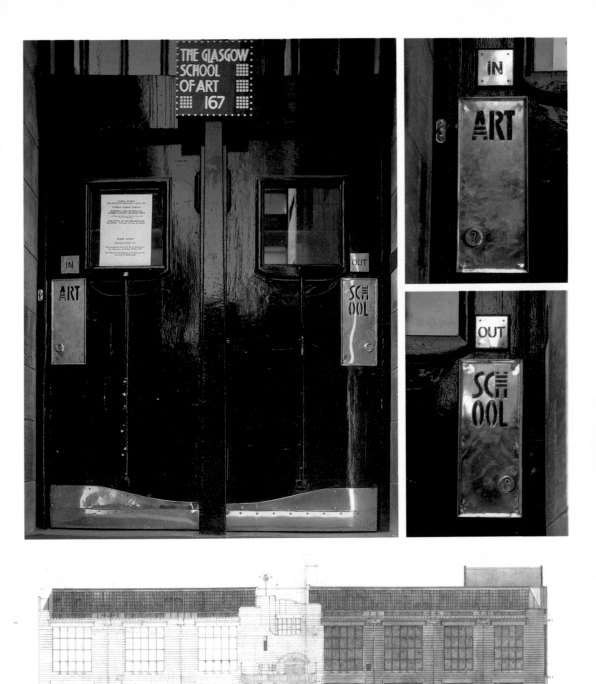

Elevation **Élévation**
Aufriss **Prospetto**

Glasgow School of Art **25**

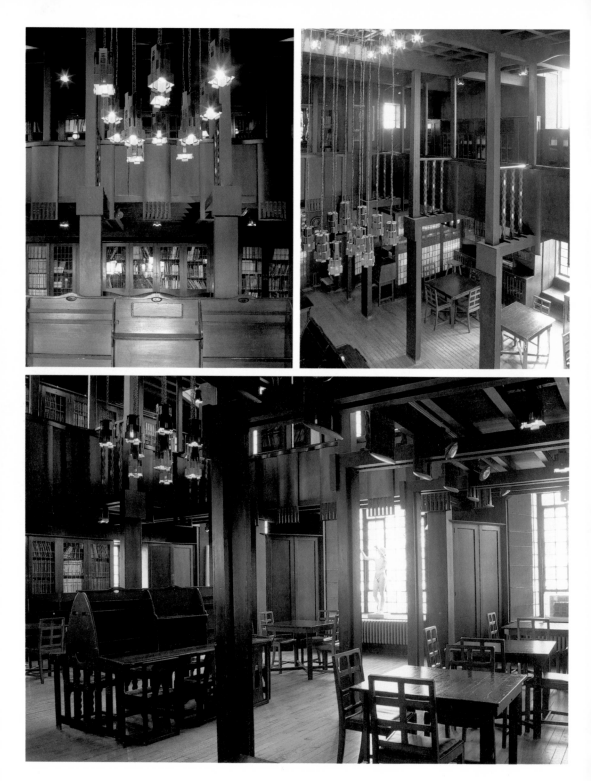

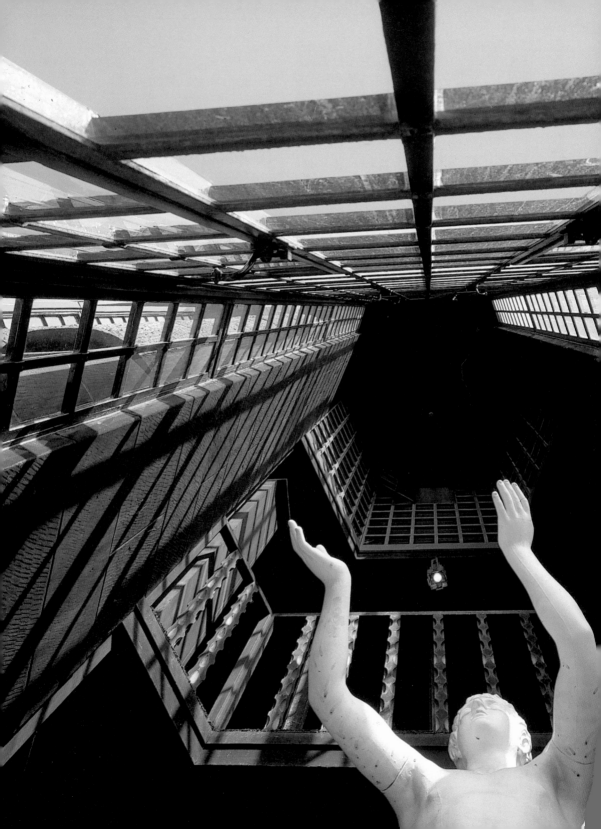

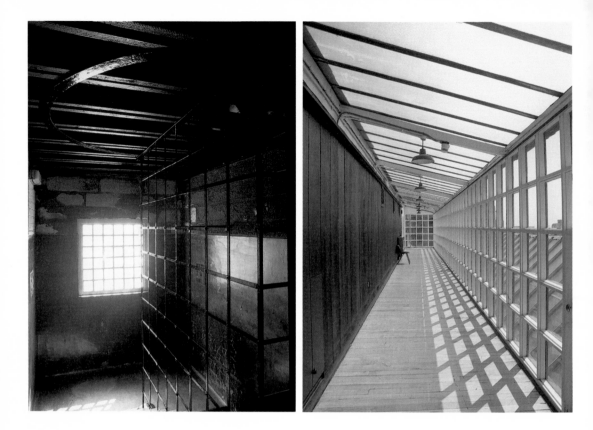

Lifts
Aufzüge
Ascenseurs
Ascensori

Ground floor
Erdgeschoss
Rez-de-chaussée
Piano terra

0 5 10

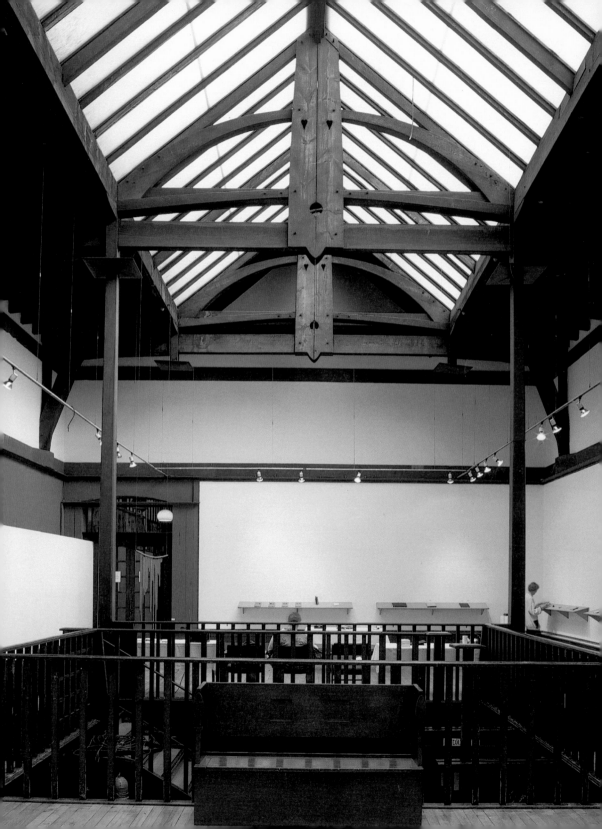

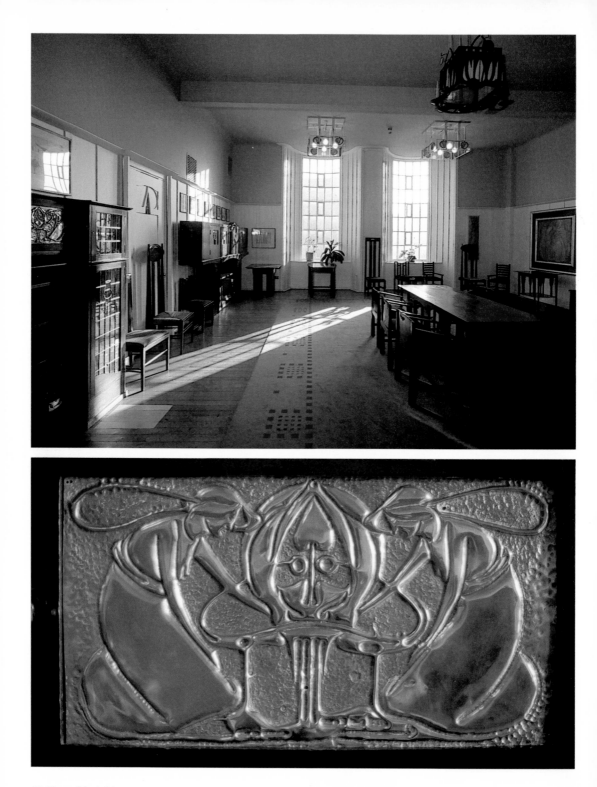

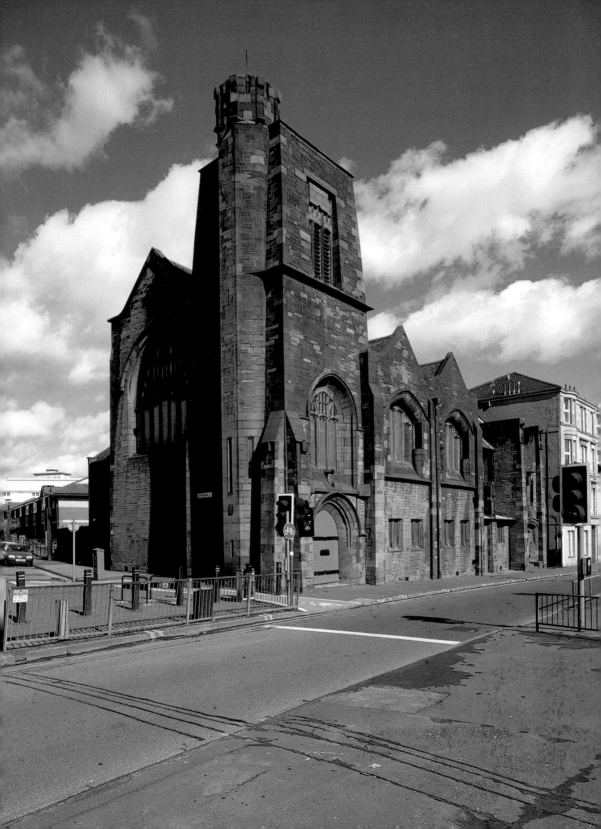

Queen's Cross Church

Garscube Road, Glasgow, UK
1898–1899

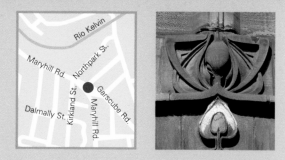

This church, previously known as St. Matthew's Free Church, is the only religious building which was built entirely by Mackintosh, though he was also responsible for the interior decoration of the Holy Trinity Church, at Bridge of Allan, and Abbey Close Church, in Paisley. The church combines Gothic and Art Nouveau features in a building with a simple ground plan. Though traditional in form, it is surprisingly modern in its use of large exposed steel beams and a dark wooden arch-shaped structure which creates a highly original decorative feature. The bell tower, which gives the building its imposing silhouette, is reminiscent of the parish church of Merriot in Somerset, which Mackintosh had visited and sketched. He also designed the oak pulpits with their carved floral motifs and green plush upholstery, the altar stone and three chairs. The magnificent stained-glass windows and the wood and stone relief designs turn the interior into a lovely arrangement of light and space. Located on the busy streets of one of Glasgow's poorest neighbourhoods, this church provides a space in which one can escape from the urban bustle.

Diese vormals unter dem Namen St. Matthew's Free Church bekannte Kirche ist das einzige sakrale Bauwerk, das zur Gänze von Mackintosh errichtet wurde. Allerdings verdanken wir ihm auch die Innenraumdekorationen von Holy Trinity in Bridge of Allan und von Abbey Close in Paisley. Mit dieser Kirche sind Stilelemente von Gotik und Art Nouveau in einem einzigen Gebäude vereint, das einen einfachen Grundriss aufweist. Obgleich traditionell in der Form, ist der Bau überraschend modern. Es wurden große sichtbare Stahlträger und als einzigartiges dekoratives Element eine bogenförmige Struktur aus dunklem Holz verwendet. Der Glockenturm, dem das Gebäude seine imposante Silhouette verdankt, erinnert an die Gemeindekirche von Merriot in Somerset, die Mackintosh vorher besucht und gezeichnet hatte. Er entwarf ebenfalls die Eichenkanzel mit geschnitzten Blumenmotiven und einem Bezug aus grünem Plüsch, den Altarstein sowie drei Stühle. Die herrlichen Glasfenster und die Reliefs aus Holz und Stein machen den Innenraum zu einem Spiel aus Licht und Raum. Die Kirche liegt an einer der verkehrsreichen Straßen und in einem der ärmsten Viertel Glasgows und bietet daher einen Raum, der Zuflucht vor dem Trubel der Stadt gewährt.

Cette église, auparavant connue sous le nom de St. Matthew's Free Church, est l'unique bâtiment religieux entièrement construit par Mackintosh; même si on lui doit aussi les décorations intérieures de Holy Trinity, à Bridge of Allan, et de Abbey Close, à Paisley. L'église mélange des éléments gothiques et des éléments d'art nouveau, dans une construction qui, d'un autre côté, présente un plan simple. Bien que traditionnelle par sa forme, elle est étonnement moderne du fait qu'il utilise des poutres apparentes en acier ainsi qu'une structure de bois sombre en forme d'arc ce qui produit un élément décoratif singulier. Le clocher qui confère à l'édifice sa silhouette imposante, rappelle l'église paroissiale de Merriot à Sommerset, que Mackintosh avait, alors, déjà visitée et dessinée. Il dessina, aussi, la chaire en chêne avec ses motifs floraux taillés et tapissée d'un tissu vert épais, ainsi que l'autel et trois chaises. Les magnifiques vitraux et les reliefs de bois et de pierre transforment l'intérieur en un jeu de lumière et d'espace. Située dans une des rues passantes d'un des quartiers les plus pauvres de Glasgow, l'église offre un espace qui permet d'échapper au tumulte urbain.

Questa chiesa, conosciuta in precedenza col nome di St. Matthew's Free Church, è l'unico edificio religioso interamente costruito da Mackintosh, anche se all'architetto si attribuiscono gli arredamenti della Holy Trinity, a Bridge of Allan, e della Abbey Close, a Paisley. La chiesa coniuga elementi gotici e art nouveau in un edificio che, nonostante ciò, presenta una pianta molto semplice. La costruzione, anche se tradizionale nella forma, è sorprendentemente moderna, visto che utilizza grandi travi a vista in acciaio, ed una struttura in legno scuro ad arco che crea un singolare elemento decorativo. Il campanile, che conferisce all'edificio un profilo imponente, ricorda la chiesa parrocchiale di Merriot a Somerset, che Mackintosh aveva già visitato e disegnato. Sono suoi anche il progetto del pulpito in rovere con motivi floreali intagliati e tappezzato di felpa verde, l'altare e tre sedie. Le magnifiche vetrate ed i bassorilievi in legno e pietra trasformano l'interno in un gioco di spazi e luci. Situata tra le strade affollate di uno dei quartieri più poveri di Glasgow, la chiesa offre uno spazio dove rifugiarsi dal frastuono urbano.

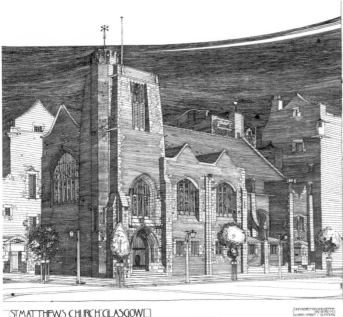

St MATTHEWS CHURCH GLASGOW
: NOW QUEENS CROSS CHURCH :
CHARLES R MACKINTOSH FRIBA

The church's stained-glass windows illuminate the interior and, together with other structural features, represent important decorative motifs which create a spacious atmosphere for church service.

Durch die Glasfenster gelangt Helligkeit in das Innere der Kirche. Zusammen mit anderen strukturellen Elementen und umfangreichen dekorativen Motiven bilden sie einen großzügigen Rahmen für den Gottesdienst.

Les vitraux de l'église illuminent l'intérieur et, unis aux autres éléments structuraux, conforment d'imposants motifs décoratifs, qui génèrent une atmosphère spacieuse consacrée au culte.

Le vetrate della chiesa illuminano l'interno e modellano, insieme ad altri elementi strutturali, importanti motivi decorativi che creano un ambiente arioso per il culto.

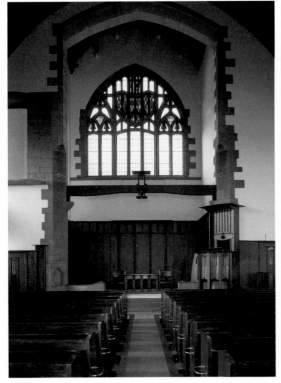

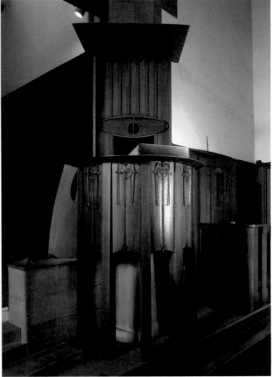

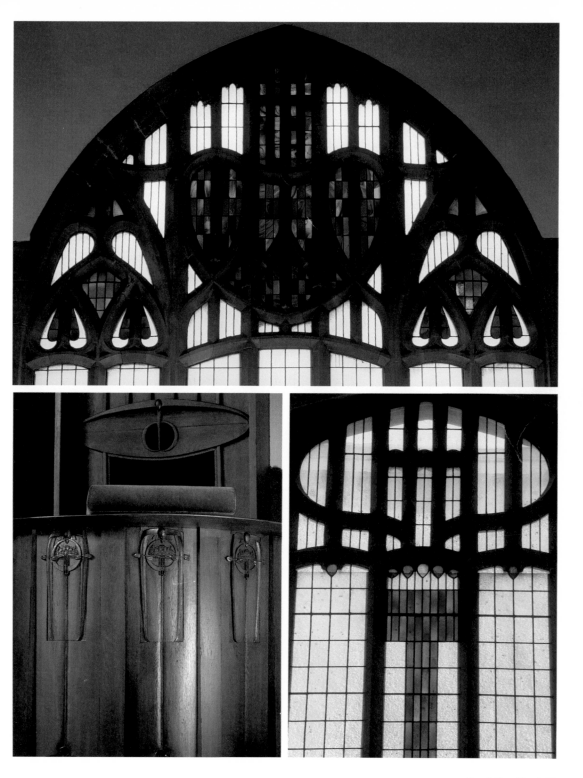

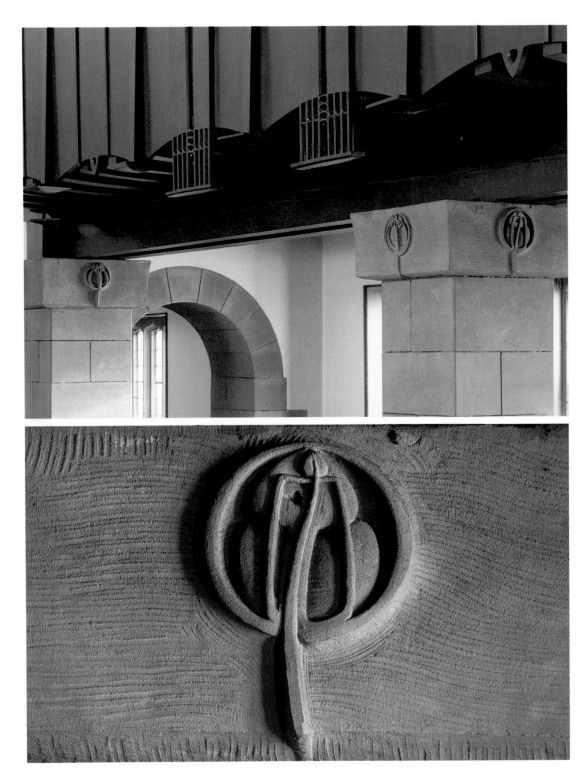

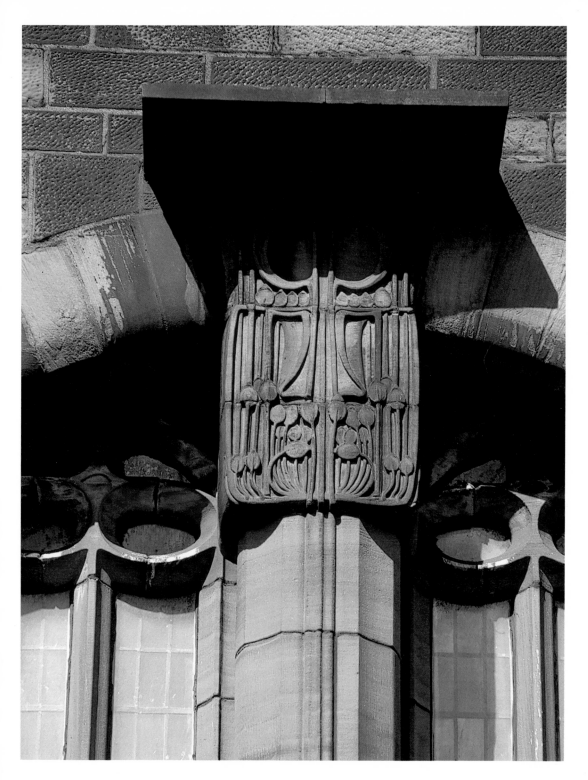

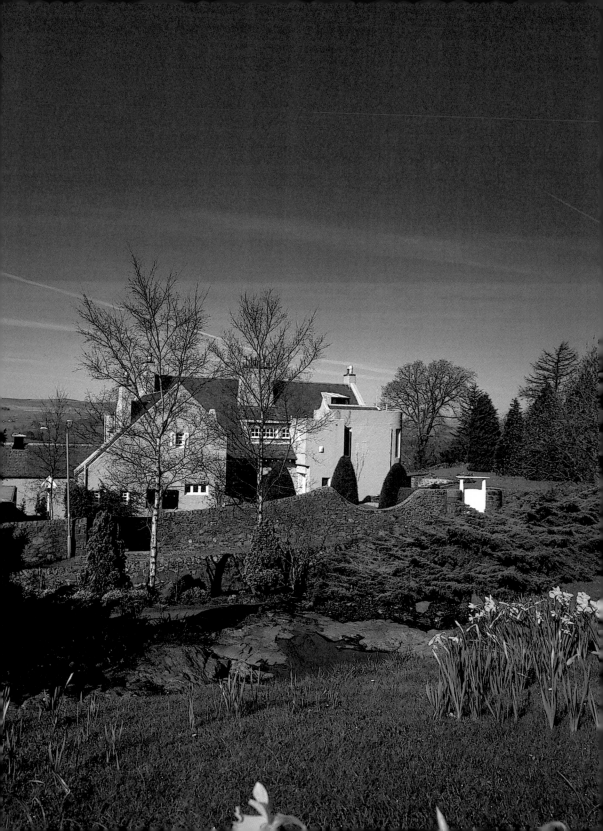

Windyhill

Kilmacolm, Renfrewshire, UK
1901

Windyhill Villa was the first private home to be designed by Mackintosh, and though subsequent owners have made alterations to it, the most recent of these has made an effort to restore the building according to its original structure. The house stands on a hill and is accessed on the north side by means of a courtyard which creates a small space for receiving visitors. The main wing of the house visually dominates the servants' wing. In keeping with the style of traditional Scottish country houses, the building has a sloping roof, rough grey rendering and a plain façade on the southern side. With this building, Mackintosh was decidedly ahead of his time, and made a great contribution to the evolution of 1920s architecture. Two examples of his innovation are the large two-metre-long horizontal window located next to the main entrance, and the stairwell which projects out of the façade. The architect also designed the furniture, which was later donated to the Glasgow School of Art. The project's unity lies in the coherence between modern and vernacular styles, in addition to the blending of ornamental and structural features.

Windyhill ist das erste von Mackintosh entworfene Privathaus. Seine verschiedenen Besitzer nahmen jeweils Veränderungen vor, aber der letzte von ihnen war doch bemüht, seine ursprüngliche Struktur zu erhalten. Das Haus liegt auf einem Hügel und ist von der Nordseite über einen Hof zugänglich, der den Besucher empfängt. In Windyhill dominiert der Hauptflügel visuell über den Dienstflügel. Ganz im Stil der traditionellen schottischen Landhäuser errichtet, zeichnet sich das Gebäude durch Schrägdächer, grauen Rauhputz sowie eine glatte Fassade an der Südseite aus. Mit diesem Haus eilte Mackintosh seiner Zeit weit voraus und leistete einen bemerkenswerten Beitrag zur Entwicklung der Architektur in den zwanziger Jahren. Beispiele hierfür sind das neben dem Haupteingang gelegene zwei Meter breite Fenster und das Treppenhaus, das über die Fassade hinausragt. Auch das Mobiliar trägt die Handschrift des Architekten und wurde später der Kunstschule von Glasgow überlassen. Die Einheitlichkeit des Projektes rührt daher, dass in ihm einerseits das Moderne und der landestypische Stil verwachsen und andererseits Ornamente und Strukturelemente kombiniert sind.

La villa Windyhill, fut l'une des premières que conçut Mackintosh et, bien que ses différents propriétaires aient effectué des modifications, le dernier d'entre eux a tenté de la restaurer suivant sa structure d'origine. Elle est située à flanc de colline, et l'on y accède depuis la face nord par une cour qui accueille le visiteur. L'aile principale de Windyhill domine visuellement l'aile de service. Respectant le style des maisons de campagne écossaises traditionnelles, la construction est dotée de toitures en pente, un crépi gris et rugueux et, côté sud, d'une façade lisse. Mackintosh, par ce bâtiment, anticipe sur son époque et contribue à l'évolution de l'architecture des années vingt. Par exemple, la grande fenêtre horizontale, longue de deux mètres, située près de l'entrée principale, ou la cage d'escalier en saillie de la façade. Le design du mobilier porte, lui aussi, la marque de l'architecte et fut légué plus tard à l'Ecole d'Art de Glasgow. L'unité du projet consiste en l'accord entre modernité et style vernaculaire, et le mélange d'ornements et d'éléments structuraux.

La villa Windyhill è stata la prima casa privata progettata da Mackintosh e, anche se ha subito delle modifiche ad opera dei differenti proprietari, l'ultimo di questi si è sforzato di restaurarla secondo la struttura originaria. Si trova ubicata su una collina e vi si accede dal lato nord, dove il visitatore viene accolto da un giardino. A Windyhill, l'ala principale domina visivamente l'ala di servizio. Seguendo lo stile delle tradizionali case di campagna scozzesi, la costruzione presenta tetti inclinati, intonaco grigio rugoso ed una facciata liscia a sud. In quest'edificio Mackintosh anticipa la propria epoca e contribuisce all'evoluzione dell'architettura degli anni venti; esempio di ciò sono la grande finestra orizzontale di due metri di lunghezza situata accanto all'ingresso principale, ed il vano della scala, che sporge dalla facciata. Anche il progetto dei mobili porta la firma dell'architetto, e fu ceduto in seguito alla Scuola d'Arte di Glasgow. L'unitarietà del progetto risiede nella coerenza tra modernità e stile nativo, e nella combinazione tra elementi decorativi ed elementi strutturali.

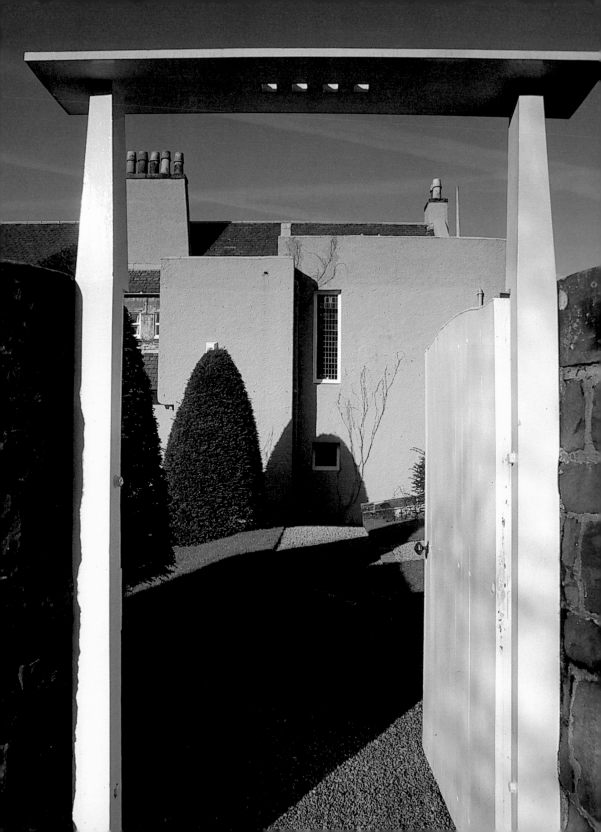

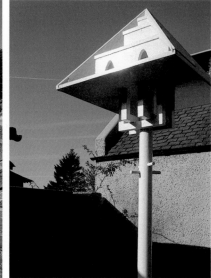

Though architecturally it is traditionally Scottish in appearance, Windyhill is an unmistakable example of modern 20th-century architecture.

Obwohl seine Bauweise dem Aussehen nach traditionell schottisch ist, steht Windyhill zweifelsohne für die moderne Architektur des 20. Jahrhunderts.

Malgré une architecture semblant écossaise traditionnelle, Windyhill représente, certainement la modernité de l'architecture du XXème siècle.

Anche se con un'architettura apparentemente legata alla tradizione scozzese, Windyhill simboleggia senza dubbio la modernità dell'architettura del XX° secolo.

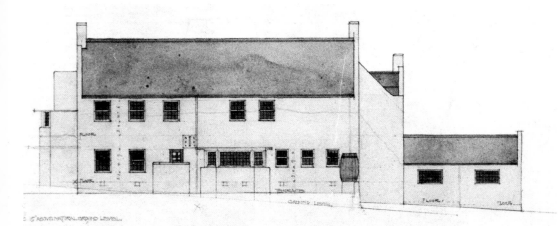

Elevation
Aufriss
Élévation
Prospetto

0 1 2

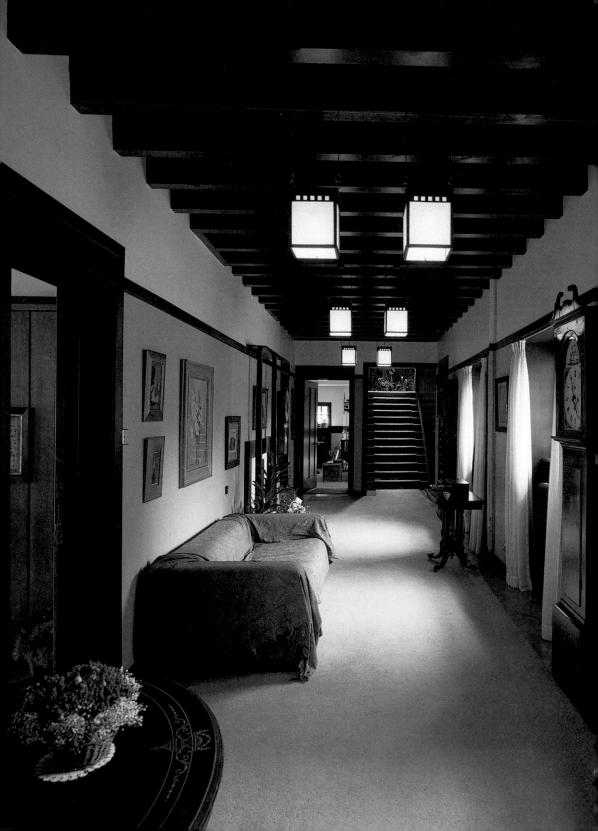

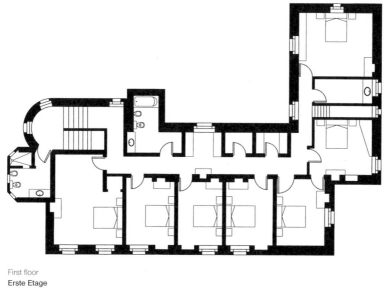

First floor
Erste Etage
Premier étage
Piano primo

0 1 2

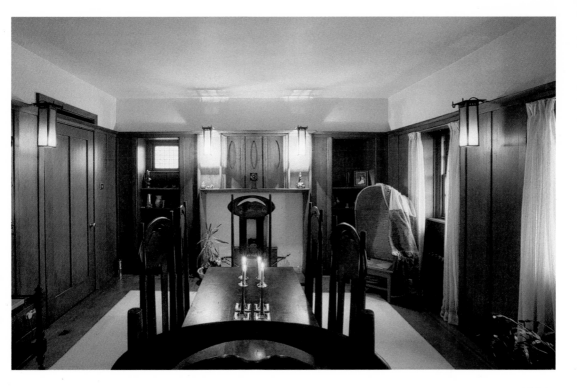

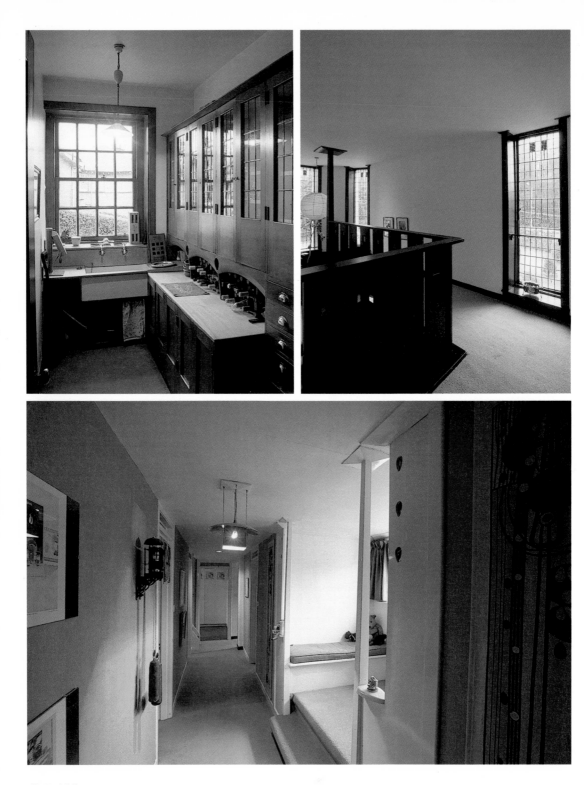

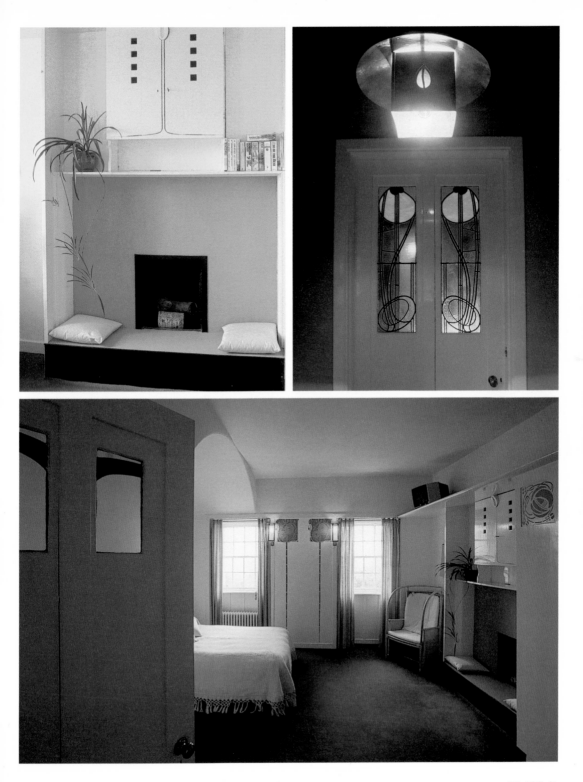

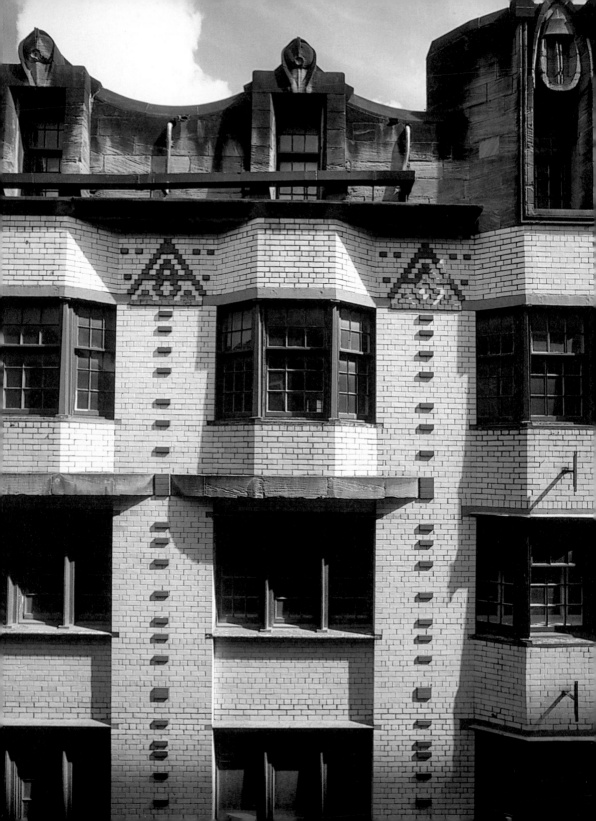

The Daily Record Building

Renfield Lane, Glasgow, UK
1900

The building stands between two hills in the city centre, and though the narrowness of the street makes it difficult to get a complete view of the structure, the design can be clearly appreciated in the perspective drawing. The tall buildings around it cast a constant shadow over the building, which emphasizes the colours Mackintosh used. The ground floor is stone, but above he used white painted bricks up to the fourth floor and red limestone for the top floor. For the façade, the architect created an arrangement of curved and straight forms, together with projections and colours. He also created geometric designs using different-coloured bricks, and highlighted the window frames in blue. The top floor crowns the building with a variation from traditional Scottish architecture: triangular undulating shapes for the lintels, while the gargoyles located above the lintels give the building its stately appearance. As in other works, Mackintosh used certain motifs to create metaphors – in this building the green tiles are used to symbolize the Tree of Life. The alternating layers of materials accentuate the forms and provide greater luminosity, particularly the white bricks in the central section.

Das Gebäude befindet sich zwischen zwei Hügeln im Stadtzentrum. Aufgrund der Enge der Straße ist es schwierig, es als Ganzes zu betrachten, aber in der Perspektivzeichnung ist der Komplex klar zu sehen. Die es umgebenden hohen Häuser werfen ständigen Schatten auf das Gebäude, der die Farbgebung Mackintoshs unterstreicht. Für das Erdgeschoss verwendete er Stein, bis zum vierten Stockwerk weiß gestrichene Ziegelsteine sowie roten Kalkstein für die Dachterrassenwohnung. An der Fassade spielte der Architekt mit gekrümmten und geraden Formen, mit Vorsprüngen und Farben. So schuf er mit Ziegelsteinen geometrische Zeichnungen in verschiedenen Tönen und hob die Fensterrahmen in Blau hervor. Die Dachterrassenwohnung schließt das Gebäude mit einer Variation der traditionellen schottischen Architektur ab: dreieckige, geschwungene Formen in den Fensterstürzen. Das herrschaftliche Aussehen verleihen ihm die Wasserspeier über den Stürzen. Wie auch bei anderen Gelegenheiten verwendete Mackintosh bestimmte Motive als Metaphern: in diesem Fall grüne Ziegel, die für den Lebensbaum stehen. Der Wechsel der Materialien lässt die Formen stärker hervortreten und verleiht dem Komplex Helligkeit.

Ce bâtiment est situé entre deux collines du centre de la ville ; et même s'il est difficile de l'apercevoir entièrement, vu l'étroitesse de la rue, on peut avoir une vision très claire de l'ensemble grâce à un dessin en perspective. Les bâtiments qui l'entourent projettent, de toute leur hauteur, une ombre constante soulignant les couleurs que Mackintosh donna à cet édifice. Le rez-de-chaussée est en pierre, mais ensuite, jusqu'au quatrième étage, il utilisa des briques peintes en blanc et une pierre calcaire rouge pour le dernier étage. Sur la façade l'architecte joue avec les formes courbes et les droites, avec les saillants et les couleurs. Ainsi, il trace des dessins géométriques avec les briques de différentes tonalités et fait ressortir les bordures des fenêtres en les peignant de bleu. Le dernier étage achève la construction par une variation de l'architecture écossaise traditionnelle : au niveau des linteaux ; des formes ondulées triangulaires. Les gargouilles placées au-dessus des linteaux concèdent un aspect seigneurial. Ici, comme en d'autres occasions, Mackintosh se sert de certains motifs pour donner lieu à des métaphores. Ainsi il est dit que les tuiles vertes évoqueraient l'arbre de la vie. L'alternance des matériaux permet d'accentuer les formes et apporte de la luminosité à l'ensemble.

Quest'immobile è situato tra le due colline del centro della città; anche se risulta difficile distinguerlo completamente a causa della larghezza insufficiente della strada, il complesso si apprezza chiaramente nel disegno in prospettiva. Gli edifici che lo circondano proiettano, con la loro altezza, un'ombra costante che sottolinea i colori che Mackintosh diede all'edificio. Il piano terra è in pietra, però al salire in altezza utilizzò mattoni dipinti di bianco fino al quarto piano e pietra calcarea rossa per l'attico. Nella facciata l'architetto gioca con forme curve e rettilinee, con gli aggetti e coi colori. Crea dunque disegni geometrici con mattoni di differenti tonalità e mette in evidenza i telai delle finestre col colore blu. L'attico termina l'edificio attraverso una variante alla tradizionale architettura scozzese: forme ondulate triangolari negli architravi. L'aspetto signorile è conferito dalle grondaie situate sopra gli architravi. Come in altre occasioni, Mackintosh utilizza alcuni motivi per originare metafore, in questo caso si dice che le tegole verdi evocherebbero l'albero della vita. L'alternanza dei materiali riesce a mettere in rilievo le forme ed apporta luminosità all'insieme.

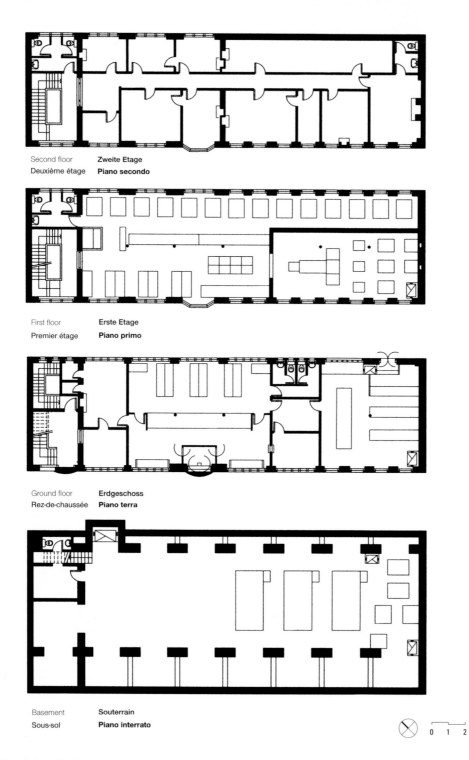

Second floor **Zweite Etage**
Deuxième étage **Piano secondo**

First floor **Erste Etage**
Premier étage **Piano primo**

Ground floor **Erdgeschoss**
Rez-de-chaussée **Piano terra**

Basement **Souterrain**
Sous-sol **Piano interrato**

0 1 2

48 The Daily Record Building

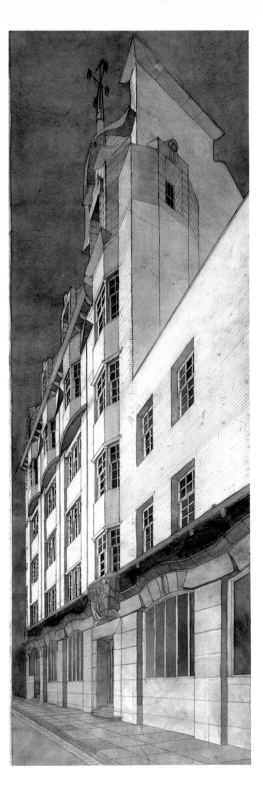

As the building is situated in a narrow street, it is difficult to get a view of the structure as a whole, though it can be seen clearly in this perspective drawing in pencil, ink and watercolour from 1901.

Das Gebäude befindet sich in einer engen Straße, was die Gesamtansicht erschwert. Sie ist nur durch diese auf 1901 datierte Perspektivzeichnung in Bleistift, Tinte und Aquarell möglich.

L'immeuble se situe dans une rue étroite, donc il est difficile d'en avoir une vue d'ensemble, qui nous est rendue par ce dessin en perspective, au crayon, encre et aquarelle, daté de 1901.

L'edificio si trova in una strada stretta ed è difficile avere una visione d'insieme se non attraverso questo disegno in prospettiva, a matita, inchiostro ed acquerello, del 1901.

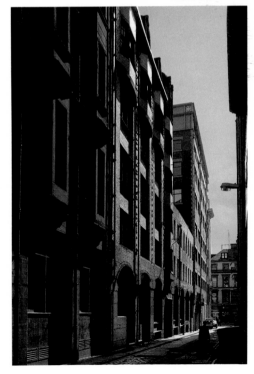

The Daily Record Building **49**

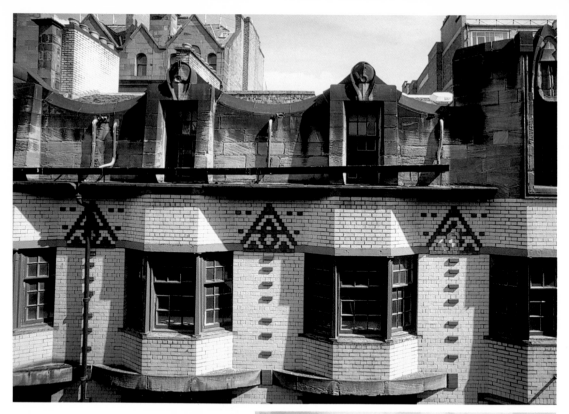

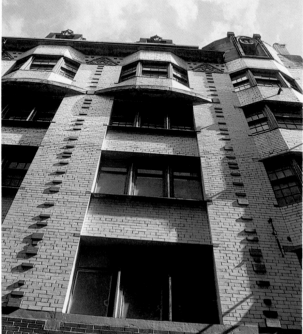

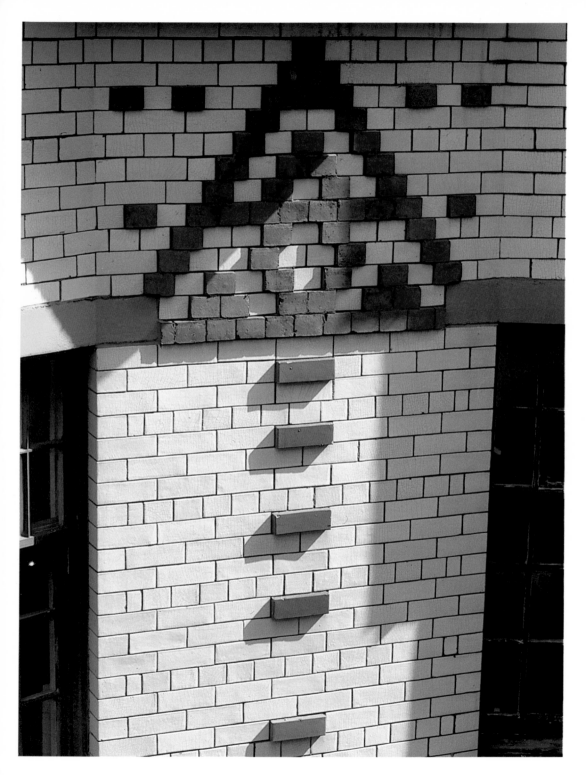

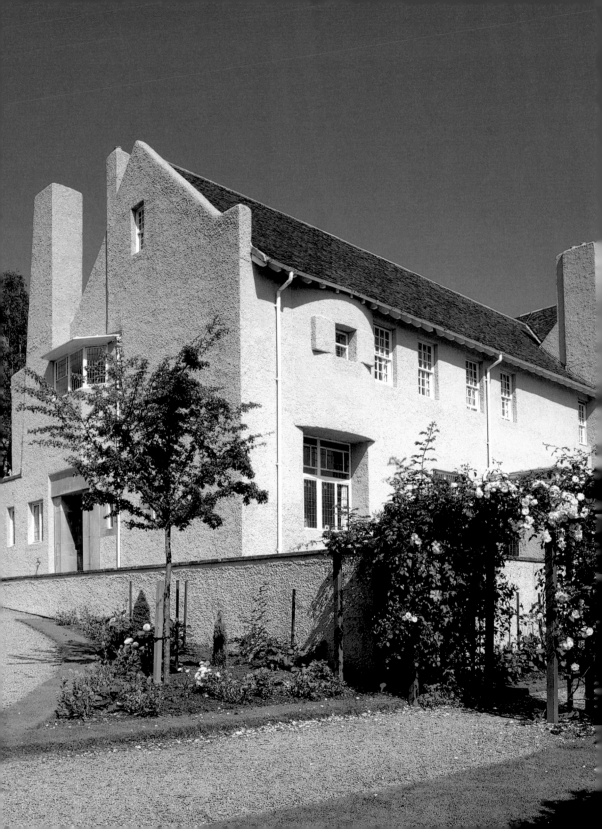

The Hill House

Upper Colquhoun Street, Helensburgh, UK
1902–1903

Standing on a hillside facing the Clyde estuary, the Hill House was one of the architect's most important residential works, as well as being one of his most unusual designs. The surrounding garden was meticulously designed by Mackintosh, who even went so far as to give explicit instructions on where each one of the trees was to be planted. The result is a composition in which there is an aesthetic unity between the lines of the landscape and the house. One particularly innovative feature is the fact that with the Hill House it was the building plans that determined the design; this was a radical departure from the method used by most of the architects of the time, who would first design the exterior. The plastered walls and the local sandstone used for the building give the house an appearance that has echoes of the Scottish Baronial tradition. For the interior, Mackintosh designed chimneys, furniture and accessories, right down to the smallest detail. Though the walls in the interior were generally white, some of them were given delicate stencils in pale colours. This house is well-integrated and adapted into its surroundings due to its form and the materials used; it also shows a definite Scottish spirit and demonstrates the architect's unique style.

Das Hill Haus, an einem Hang an der Mündung des Clyde gelegen, war einer der überraschendsten und weitreichendsten Entwürfe Mackintoshs für Wohngebäude. Er entwarf die es umgebenden Gartenanlagen auf das Sorgfältigste und gab sogar ausführliche Anweisungen zur Platzierung jedes einzelnen Baumes. Das Ergebnis ist eine Komposition, bei der die Linien der Landschaft und des Wohngebäudes eine ästhetische Einheit bilden. Als innovative Vorgehensweise ist hervorzuheben, dass die Bauzeichnungen die Gestaltung der Fassade bestimmten. Dies stand ganz im Gegensatz zu der von den meisten Architekten jener Zeit angewandten Methode zuerst das Äußere zu entwerfen. Der Verputz der Wände und der für ihre Errichtung eingesetzte örtliche Sandstein machen das Haus zu einem Abbild der Traditionen des schottischen Adels. Für die Innenräume entwarf Mackintosh Kamine, Möbel und Accessoires und achtete dabei auf die kleinsten Details. Auch wenn die Innenwände überwiegend Weiß sind, weisen doch einige zarte Schablonenmalereien in blassen Farben auf. Dieses Wohngebäude passt sich durch die verwendeten Formen und Werkstoffe hervorragend in seine Umgebung ein, zeigt aber auch den schottischen Geist und vor allem den besonderen Stil des Architekten.

La Maison Hill, située sur un versant orienté vers l'estuaire Clyde, fut une des œuvres résidentielles les plus surprenantes et de plus grande envergure de l'architecte. Les jardins qui l'entourent furent méticuleusement dessinés par Mackintosh, qui parvint à fournir des instructions explicites sur l'emplacement de chaque arbre. Le résultat offre une composition dans laquelle les lignes du paysage et de l'habitation forment une unité esthétique. Il est à noter que, comme procédé novateur, les plans de la construction déterminèrent ceux de la façade, contrairement à la méthode habituelle de la plus part d'architectes de l'époque qui dessinaient en premier l'extérieur. L'utilisation du grès local dans la construction et le crépi des murs restituent à la maison une image qui correspond à la tradition écossaise noble. Pour la partie intérieure, Mackintosh dessina les cheminées, les meubles et les accessoires, soignant les moindres détails. Bien que la majorité des murs fût de couleur blanche, quelques-uns présentent de délicats poncifs de couleurs pâles. Cette demeure est adaptée à son environnement par sa forme et par les matériaux utilisés et elle démontre aussi l'esprit écossais.

La Casa Hill, situata su un pendio orientato verso l'estuario Clyde, fu uno dei progetti residenziali più sorprendenti e di maggior portata dell'architetto. I giardini che la circondano furono progettati meticolosamente da Mackintosh, che arrivò a dare istruzioni esplicite sulla collocazione di ciascuno degli alberi. Il risultato è una composizione nella quale le linee del paesaggio e quelle della casa formano una vera unità estetica. Come processo innovativo, bisogna rilevare che le piante della costruzione determinarono il progetto della facciata, contrariamente al metodo della maggior parte degli architetti del momento, che progettava prima l'esterno. L'intonaco delle pareti e l'arenaria locale che si utilizzò per la sua realizzazione, conferiscono alla casa un'immagine che corrisponde all'illustre tradizione scozzese. All'interno Mackintosh progettò caminetti, mobili ed accessori, curando tutti i particolari. Anche se le pareti interne erano prevalentemente color bianco, alcune presentavano delicati stencils dai colori pallidi. Questa residenza si adatta all'intorno per la forma ed i materiali che utilizza, ma rispecchia lo spirito scozzese e, soprattutto, lo stile particolare dell'architetto.

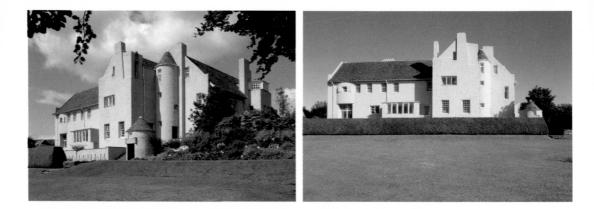

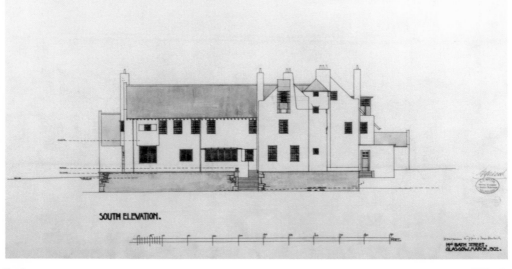

SOUTH ELEVATION.

Hª BATH STREET,
GLASGOW. MARCH .1902.

Elevation
Aufriss
Élévation
Prospetto

0 1 2

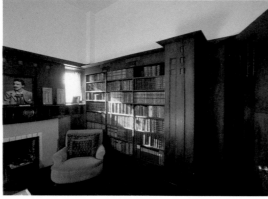

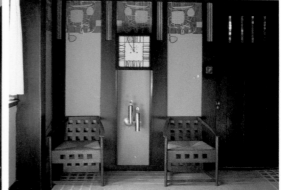

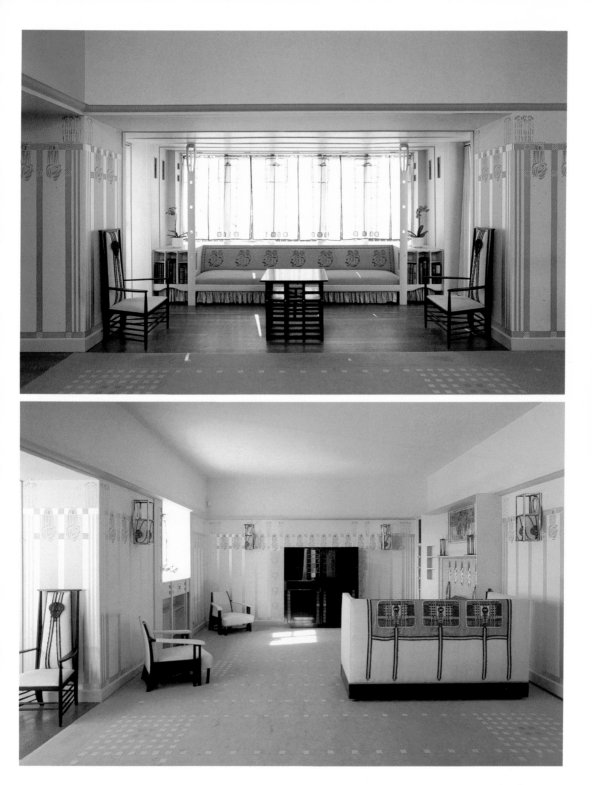

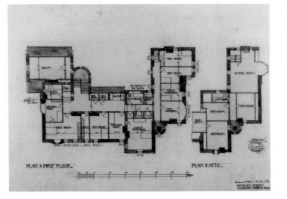

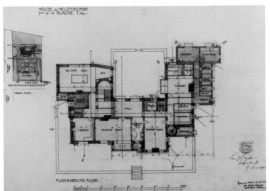

Original drawings by Mackintosh
Originalzeichnungen von Mackintosh
Dessins originaux de Mackintosh
Disegno originale da Mackintosh

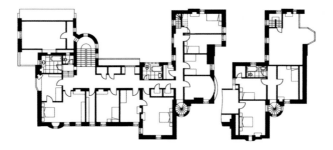

First floor and attic
Erste Etage und Dachgeschosswohnung

Premier étage et atique
Piano primo e attico

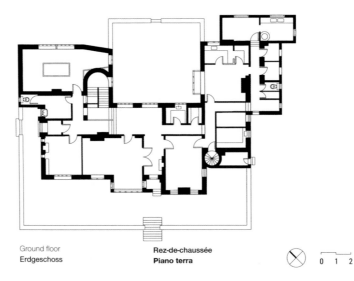

Ground floor
Erdgeschoss

Rez-de-chaussée
Piano terra

0　1　2

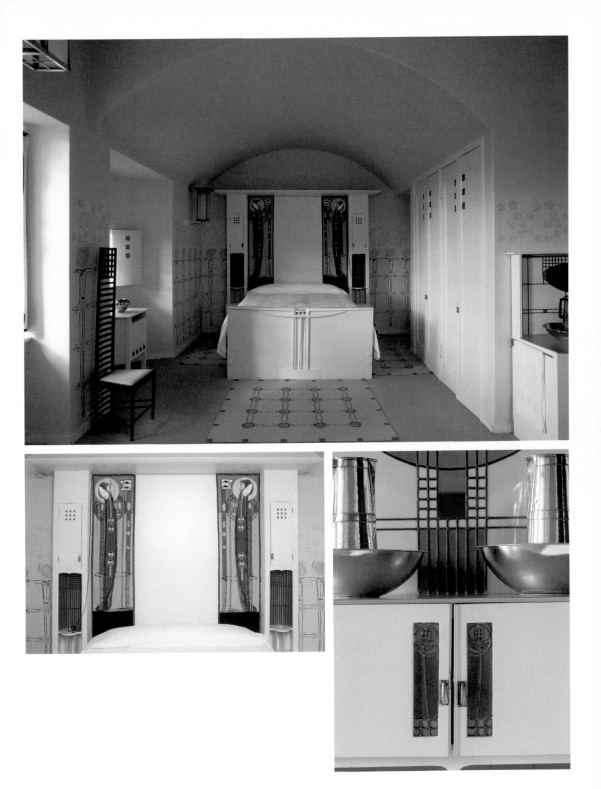

Willow Tea Rooms

217 Sauchiehall Street, Glasgow, UK
1903

Mackintosh designed both the structure and the decor and took his inspiration from the theme of "willows", which he derived from the name of the street ("Sauchiehall" means "willow" in Scottish). His wife, Margaret Macdonald, also contributed in the creation of the café's interior atmosphere and decor. The Willow Tea Rooms remained open until 1920, after which it became part of the shop Daly's. Although the original design has been altered, the ambience of the structure has been conserved and the "room de luxe" is still intact. This four-storey building, which stands on a narrow piece of land, contained several tea rooms, two dining rooms, a gallery-cum-dining room and a wood-lined billiard room on the top floor. Between 1917 and 1919, Mackintosh designed an enlargement to the basement which evoked the interior of a wartime bunker. The "room de luxe" is the most complete and well-known of the rooms: it features chairs with high backrests, white walls and tablecloths, crockery with willow motifs and the famous leaded glass door.

Mackintosh übernahm sowohl die Struktur als auch die Dekoration dieses Teesalons und ließ sich dabei thematisch von Weiden („Willows") inspirieren. Er leitete dies ab von der Lage des Lokals in einer Straße mit dem Namen „Sauchiehall", der schottischen Bezeichnung für Weidenlandschaft. Seine Frau Margaret Macdonald trug ebenfalls zur Schaffung der Atmosphäre und der Dekoration des Cafés bei, das bis 1920 in Betrieb war und dann in die Ladenkette Daly's einging. Das Originaldesign wurde zwar verändert, aber das Ambiente des Gesamtkomplexes und der „room de luxe" sind noch intakt. Das viergeschossige Gebäude ruht auf einem schmalen Gelände und sein Inneres beherbergt mehrere Teeräume, zwei Speisesäle, einen Speisesaal mit Galerie sowie ein Billardzimmer aus Holz im obersten Stockwerk. Zwischen 1917 und 1919 entwarf Mackintosh eine Erweiterung des Kellergeschosses mit Anspielungen auf den Krieg, die an einen Bunker erinnerten. Der „room de luxe" ist der am vollständigsten erhaltene und bekannteste Raum; hier sind die Stühle mit hoher Rückenlehne, die weißen Wände und Tischtücher, das Geschirr mit Weidenmotiven und die berühmte Tür aus Bleiglas hervorzuheben.

Mackintosh se chargea de la structure tout comme de la décoration de ce salon de thé et s'inspira du thème des saules (« willows »), profitant de l'emplacement du local dans la rue Sauchiehall, mot écossais qui signifie le passage des saules. Son épouse, Margaret Macdonald, contribua, elle aussi, à la création de l'atmosphère et à la décoration du café, exploité jusqu'en 1920, date à laquelle il fut incorporé aux boutiques Daly's. Quoique le design original ait été modifié, l'ambiance de l'ensemble a été conservée et le « room de luxe » reste intact. Le bâtiment se situe sur un terrain étroit, et il héberge divers salons de thé, deux restaurants, une galerie-restaurant et une salle de billard en bois au dernier étage. Entre 1917 et 1919, Mackintosh dessina un agrandissement du sous-sol, avec des connotations belliqueuses évoquant un bunker. Le « room de luxe » est la pièce la plus achevée et la plus connue : on y remarque les chaises à dossiers hauts, les parois et les nappes blanches, la vaisselle aux motifs de saules et la fameuse porte de verre plombé.

Mackintosh si incaricò sia della parte strutturale che dell'arredamento di questa sala da tè e prese ispirazione dai salici ("willows"), approfittando della collocazione del locale in via Sauchiehall, parola scozzese che significa paesaggio di salici. Anche sua moglie, Margaret Macdonald, contribuì alla creazione dell'atmosfera e dell'arredamento del caffè, che continuò a funzionare fino al 1920, data in cui fu integrato ai negozi Daly's. Anche se il progetto originale è stato modificato, è stata mantenuta l'atmosfera del complesso e la "room de luxe" è ancora intatta. L'edificio, a quattro piani, si insedia su un terreno di larghezza ridotta, ed al suo interno ospita diverse sale da tè, due sale da pranzo, una galleria-pranzo ed una sala da biliardo in legno all'ultimo piano. Tra il 1917 ed il 1919, Mackintosh progettò un ampliamento della cantina con connotazioni belliche che evocavano un bunker. La "room de luxe" è la sala più completa e più conosciuta; vi fanno spicco le sedie dallo schienale alto, le pareti e le tovaglie bianche, il vasellame con motivi di salici e la famosa porta di vetro piombato.

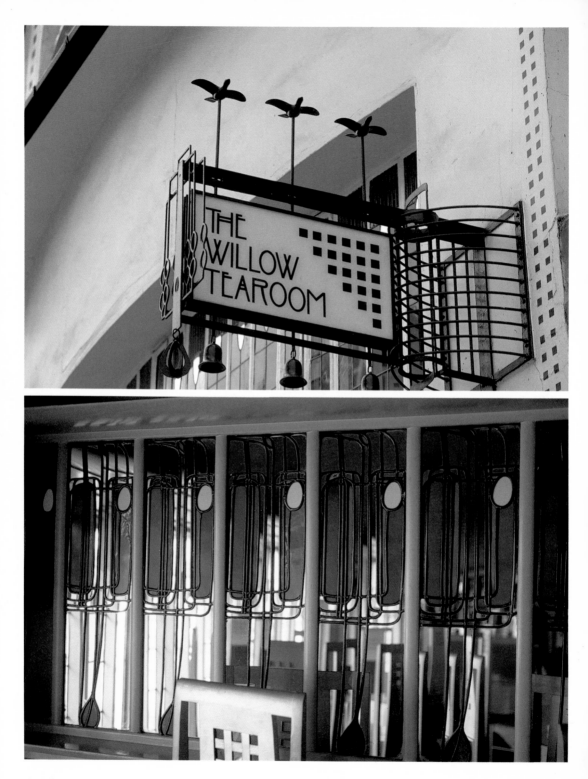

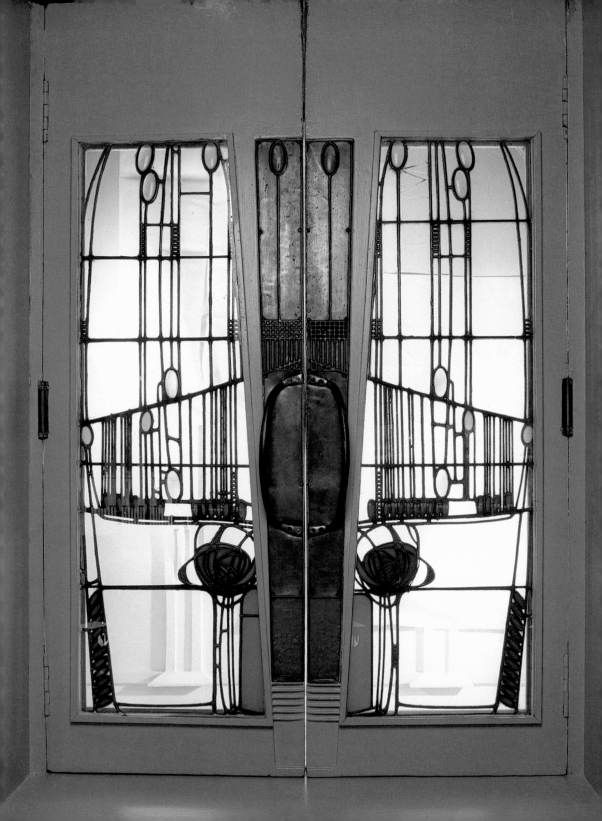

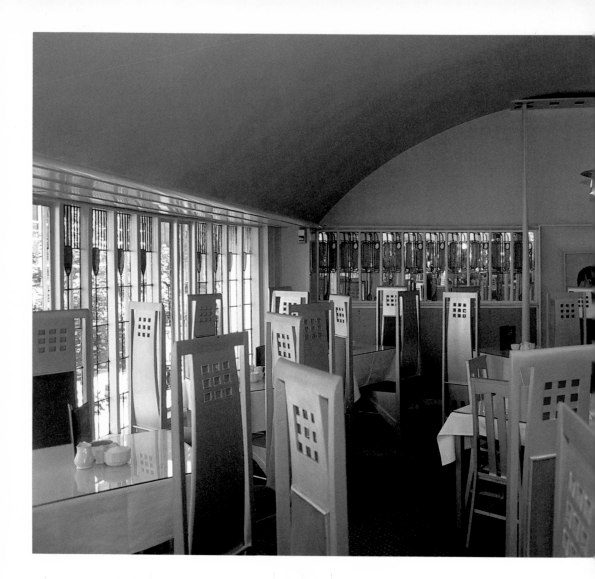

Elevations
Aufrisse
Élévations
Prospetti

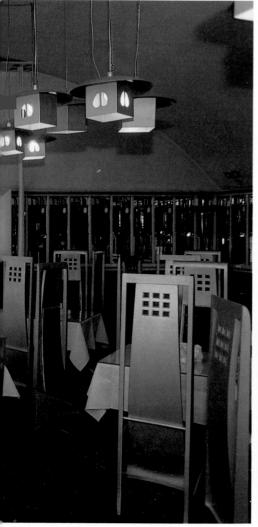

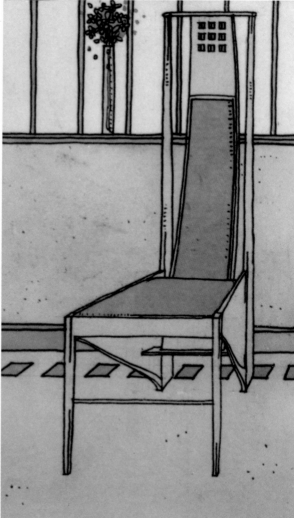

The "room de luxe" is one of Mackintosh's most well-known interiors, and also includes furniture designed by the architect.

Der „room de luxe" ist einer der bekanntesten Innenräume von Mackintosh, der auch die Möbel entwarf.

Le « room de luxe » est l'un des intérieurs les plus connus de Mackintosh, qui se chargea aussi du design des meubles.

La "room de luxe" è uno degli interni più conosciuti di Mackintosh, che si occupò anche del progetto dei mobili.

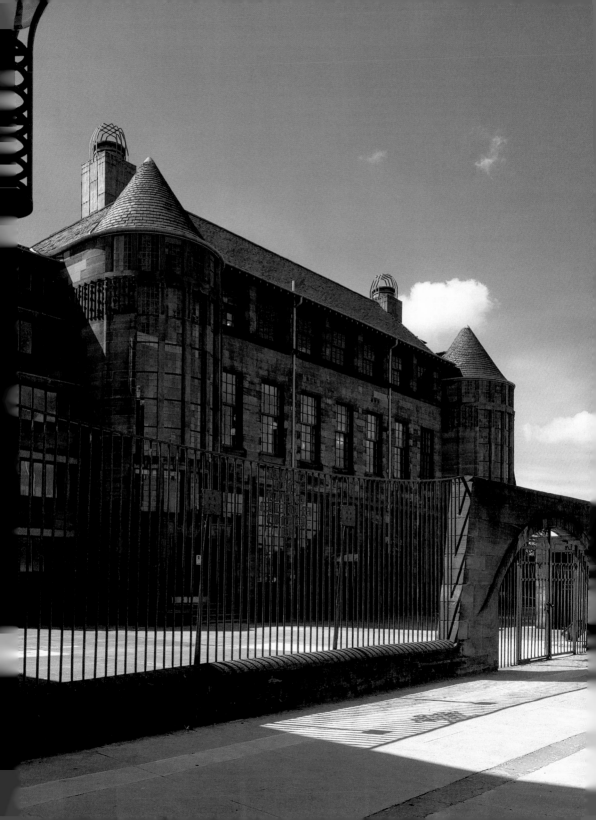

Scotland Street School

Scotland Street, Glasgow, UK
1904

In this project Mackintosh had to submit to a few restrictive conditions, which included a meagre budget and the fact that the school would only have 21 classrooms for 1,250 students, and thus the decor of the building shows an austere sobriety. The horizontal extension of this red limestone volume – which shows great plasticity – is broken by two vertical towers which contain the stairwells. The architect made them very wide so that hundreds of children could go up and down them at the same time. They are illuminated by enormous windows, the modernity of which presages Walter Gropius' metal and glass stairway (Factory and Offices, model for the 1914 Cologne Exhibition). However, the conical roofs are a clear allusion to traditional Scottish architecture. The most innovative features of the school are the two rows of horizontal windows which frame the stairwells. The interiors are spacious and the walls and pillars are surfaced with white tiles. The entrance hall is articulated in such a way that it can be used as a theatre space.

Bei diesem Projekt musste sich Mackintosh an einige Einschränkungen halten. Darunter fielen ein spärliches Budget und die Tatsache, dass die Schule über nur 21 Klassenräume für 1.250 Schüler verfügte, was die von nüchterner Strenge gezeichnete Dekoration des Gebäudes erklärt. Die horizontale Entwicklung dieses Blockes aus rotem Kalkstein, der sich durch extreme Plastizität auszeichnet, wird durch die beiden vertikalen Türme durchbrochen, in denen sich die Treppenhäuser befinden. Der Architekt gestaltete sie äußerst breit, damit sich Hunderte von Kindern gleichzeitig in ihnen bewegen konnten. Der Lichteinfall erfolgt durch riesige Fenster, deren moderne Gestaltung bereits die Treppe aus Glas und Holz von Walter Gropius ankündigt (Fabrik und Büros, Modell der Ausstellung in Köln 1914). Dennoch sind die kegelförmigen Dächer eine klare Anspielung auf die traditionelle schottische Bauweise. Die innovativsten Elemente der Schule sind die beiden horizontalen Fensterreihen, die die Treppenhäuser umrahmen. Das Innere ist äußerst geräumig und die Wände und Pfeiler wurden mit weißen Kacheln verkleidet. Die Eingangshalle ist so unterteilt, dass sie als Theaterraum verwendet werden kann.

Pour ce projet, Mackintosh dut se plier à quelques conditions restrictives, parmi lesquelles un maigre budget et le fait que l'école ne disposerait que de 21 classes pour un effectif de 1250 élèves ; voilà pourquoi la décoration du bâtiment présente une austère sobriété. L'étendue horizontale de ce volume de pierre calcaire rouge d'une grande plasticité est rompue par la présence des deux tours verticales, où sont situées les cages d'escaliers. L'architecte les conçut de grande ampleur, afin que puissent y circuler des centaines d'élèves en même temps. Elles sont illuminées par d'énormes baies vitrées dont la modernité annonce, dès lors, l'escalier de verre et de métal de Walter Gropius (Usine et Bureaux, modèle de l' Exposition de Cologne de 1914) ; cependant, les plafonds coniques sont une allusion évidente à l'architecture écossaise traditionnelle. Les éléments les plus innovateurs, sont les deux rangées de fenêtres horizontales qui encadrent les cages d'escalier. Les intérieurs sont spacieux, les murs et les piliers sont recouverts de carreaux de faïence blancs. Le vestibule est articulé de façon à ce que l'on puisse l'utiliser comme espace théâtral.

In questo progetto Mackintosh dovette attenersi ad alcune condizioni restrittive, tra queste un preventivo modesto ed il fatto che la scuola disponesse di sole 21 classi per 1250 alunni; per questo motivo la decorazione dell'edificio risponde a un'austera sobrietà. Lo sviluppo orizzontale di questo volume di pietra calcarea rossa di grande plasticità, si spezza contro le due torri verticali, dove sono situati i vani delle scale. L'architetto le progettò di ampie dimensioni perché vi potessero circolare centinaia di bambini allo stesso tempo. Sono illuminate da enormi finestrature la cui modernità annuncia già la scala in ferro e vetro di Walter Gropius (Fabbrica ed Uffici, riproduzione dell'esposizione di Colonia del 1914); ciò nonostante i tetti conici sono una chiara allusione all'architettura scozzese tradizionale. Gli interni sono spaziosi e le pareti ed i pilastri sono rivestiti di piastrelle bianche. L'atrio è articolato in modo da poter essere utilizzato come spazio teatrale.

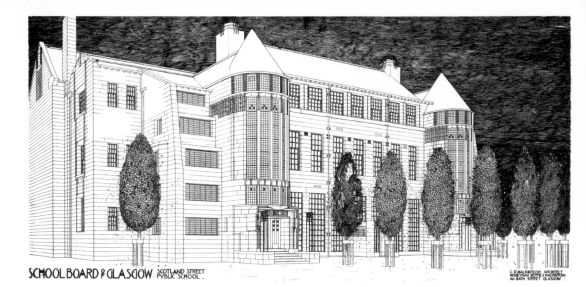

SCHOOL BOARD ℉ GLASCOW SCOTLAND STREET PVBLIC SCHOOL.

C.R.MACKINTOSH ARCHITECT
HONEYMAN KEPPIE & MACKINTOSH
140 BATH STREET GLASGOW.

Sketch of the façade
Entwurf der Fassade
Esquisse de la façade
Skizzo della facciata

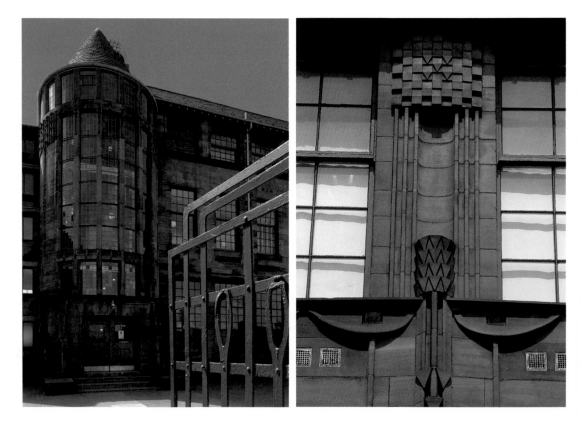

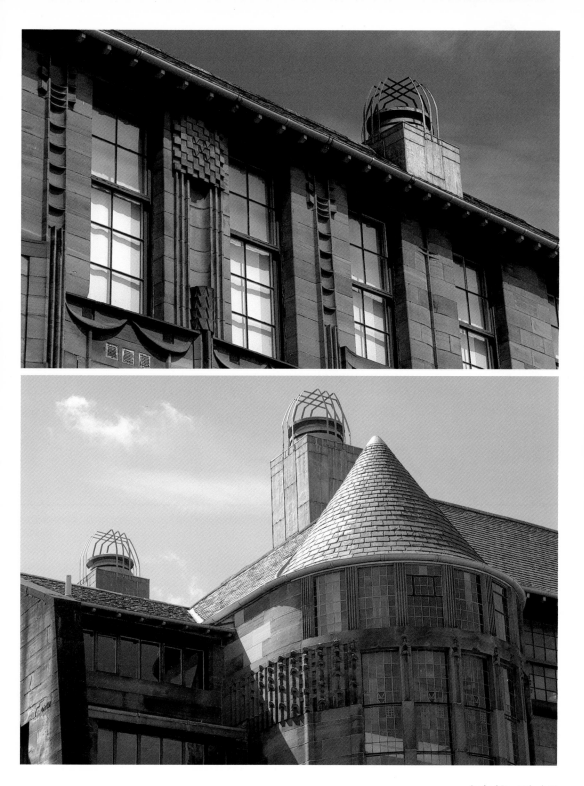

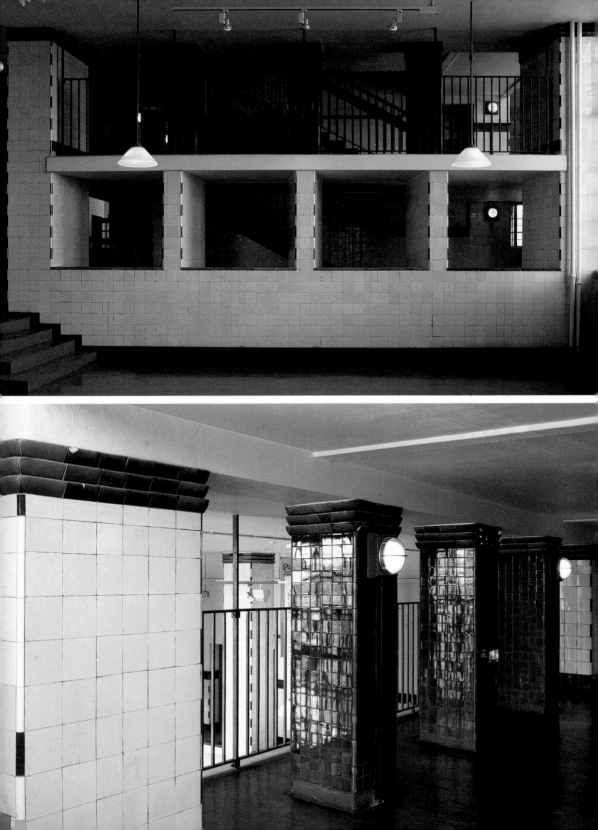

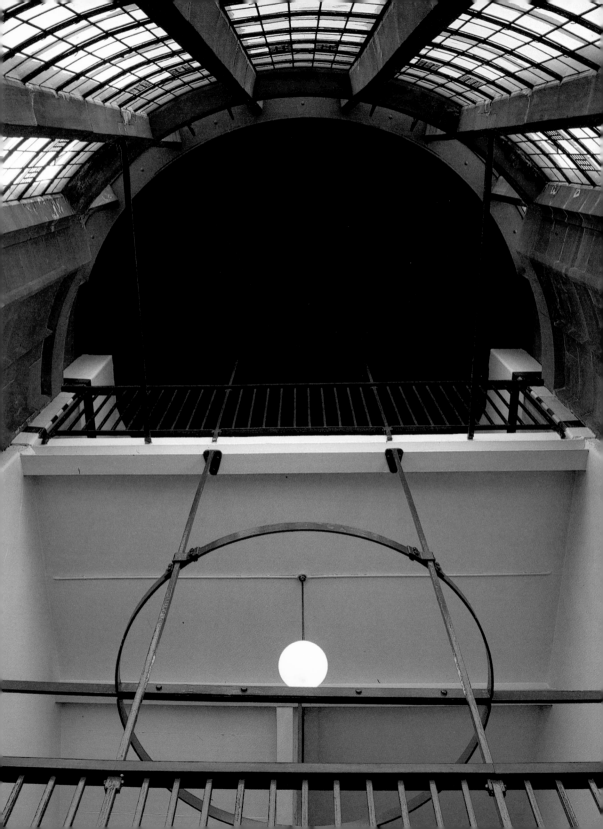

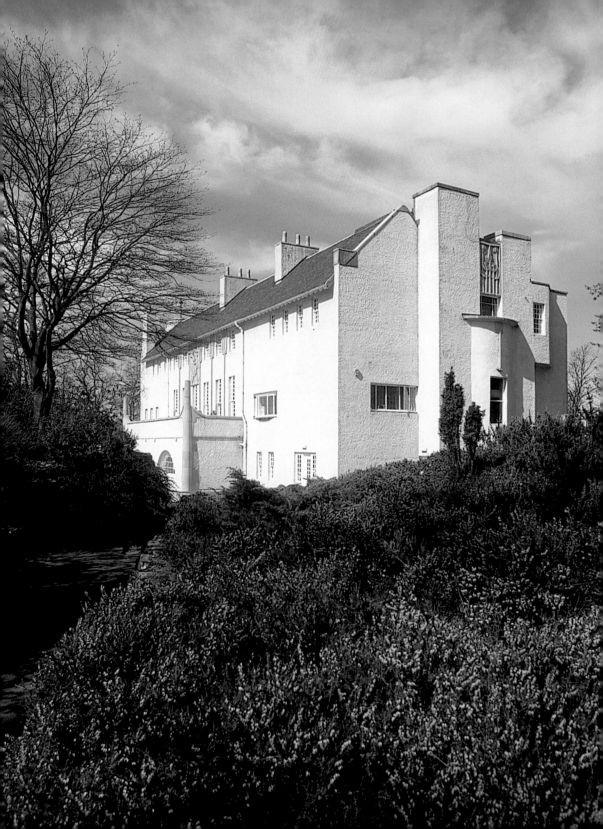

House for an Art Lover

Bellhouston Park, Glasgow, UK
1989

The design for this house, which was to be built for an art lover, was Mackintosh's entry for a competition organized in 1901 by a German magazine. Though no first prize was awarded, the jury was very enthusiastic about Mackintosh's design, and a year later the drawings were published. The house was not built until almost a century later, in 1989, inspired by the original drawings of the architect, and built by John Kane and Graeme Robertson. Building was supervised by Andrew MacMillan. It is now used as accommodation for final year students at Glasgow School of Art. With this building Mackintosh employed a central theme when designing the decoration, as he did in other works. The main hall distributes the different areas on the first floor: the dining room is based around the theme of "roses" and shows all the great skill and care that are characteristic of the architect. The same applies to the music room, which contains a specially designed piano, and the oval room, which was designed as a space reserved for women and is decorated in a symbolic manner.

Der Entwurf des für einen Kunstliebhaber gedachten Hausest war die Antwort Mackintoshs auf einen im Jahre 1901 von einer deutschen Zeitschrift ausgeschriebenen Wettbewerb. Der erste Preis wurde zwar nicht verliehen, aber dafür nahm die Jury mit großer Begeisterung Mackintoshs Entwurf auf, so dass seine Zeichnungen ein Jahr später veröffentlicht wurden. Der Bau wurde jedoch erst fast ein halbes Jahrhundert später realisiert. Im Jahr 1989 kam es durch John Kane und Graeme Robertson unter der Leitung von Andrew MacMillan endlich zur Umsetzung der Originalzeichnungen des Architekten. Derzeit beherbergt das Gebäude Studenten im letzten Jahr der Kunstschule von Glasgow. Mackintosh wählte hier wie bei anderen Arbeiten ein zentrales Thema, von dem ausgehend er die Dekoration des Wohnhauses entwarf. Die Haupteingangshalle gliedert die verschiedenen Bereiche des Erdgeschosses: Das Esszimmer nimmt das Thema „Rose" auf, ebenso wie der Musikraum, der ein speziell entworfenes Klavier enthält, und das ovale Zimmer, einem den Frauen vorbehaltenen Raum mit symbolischer Dekoration.

Le projet de cette demeure destinée à un amateur d'art fut la proposition que Mackintosh élabora en réponse à un concours organisé par une revue allemande en 1901. Le premier prix resta vacant, mais le jury accueillit avec un grand enthousiasme le projet de Mackintosh, ainsi ils publièrent ses dessins l'année suivante. Ce n'est que près d'un siècle plus tard, en 1989, que la construction a été terminée, par John Kane et Graeme Robertson, sous la direction de Andrew MacMillan, respectant les dessins originaux de l'architecte. Actuellement, l'école accueille les élèves en dernière année de l'Ecole d'Art de Glasgow. Comme dans d'autres de ses œuvres, Mackintosh s'inspire, ici, d'un thème central pour élaborer la décoration de la demeure. Le vestibule principal distribue les différents espaces du premier étage : la salle à manger est basée sur le thème de la rose, ainsi que le salon de musique, qui abrite un piano dessiné spécialement, et que la chambre ovale, conçue comme un espace réservé aux femmes arborant une décoration symbolique.

Il progetto di questa casa destinata ad un appassionato d'arte fu la risposta di Mackintosh ad un concorso bandito da una rivista tedesca nel 1901. Il primo premio rimase deserto, ma la giuria accolse con grande entusiasmo il progetto di Mackintosh, così che un anno più tardi vennero pubblicati i suoi disegni. La costruzione non fu terminata che quasi un secolo dopo, nel 1989, ispirata ai disegni originali dell'architetto, ad opera di John Kane e Graeme Robertson e sotto la direzione di Andrew MacMillan. Attualmente accoglie gli studenti dell'ultimo anno della Scuola d'Arte di Glasgow. Mackintosh utilizza qui un tema centrale, come fa in altre opere, per progettare l'arredamento dell'alloggio. L'atrio principale distribuisce i diversi spazi del primo piano: la sala da pranzo è basata sul tema della rosa; lo stesso accade alla sala di musica, che ospita un piano progettato in modo speciale, ed alla stanza ovale, impostata come spazio riservato alle donne e che è decorata allegoricamente.

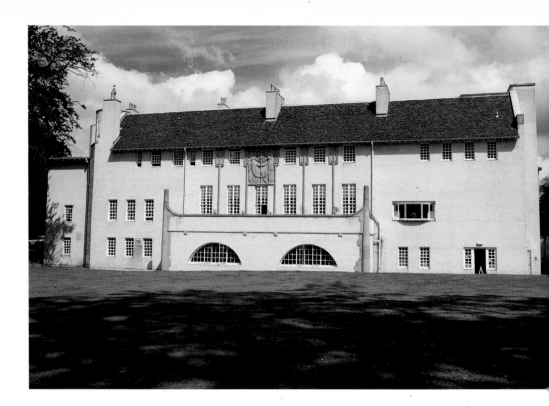

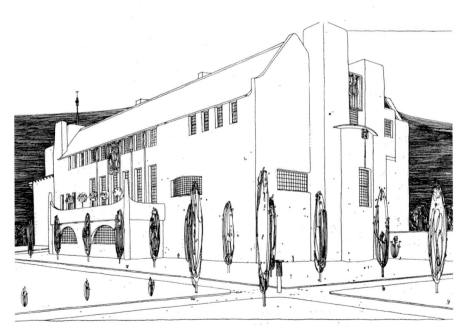

Prespective
Prespective

Perspektivzeichnung
Prospettiva

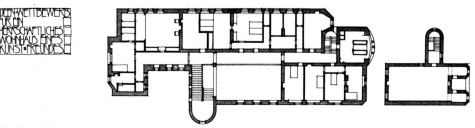

First floor and attic
Erste Etage und Dachgeschosswohnung
Premier étage et attique
Piano primo e attico

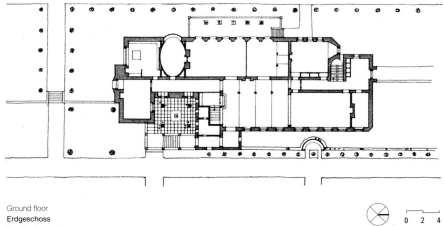

Ground floor
Erdgeschoss
Rez-de-chaussée
Piano terra

0 2 4

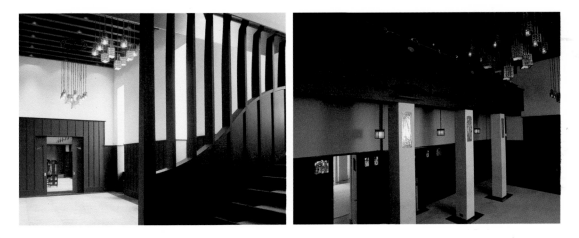

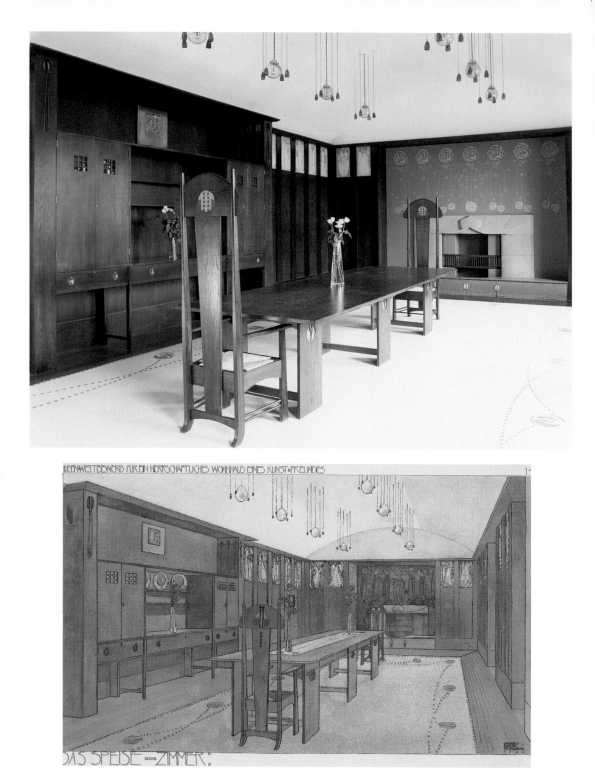

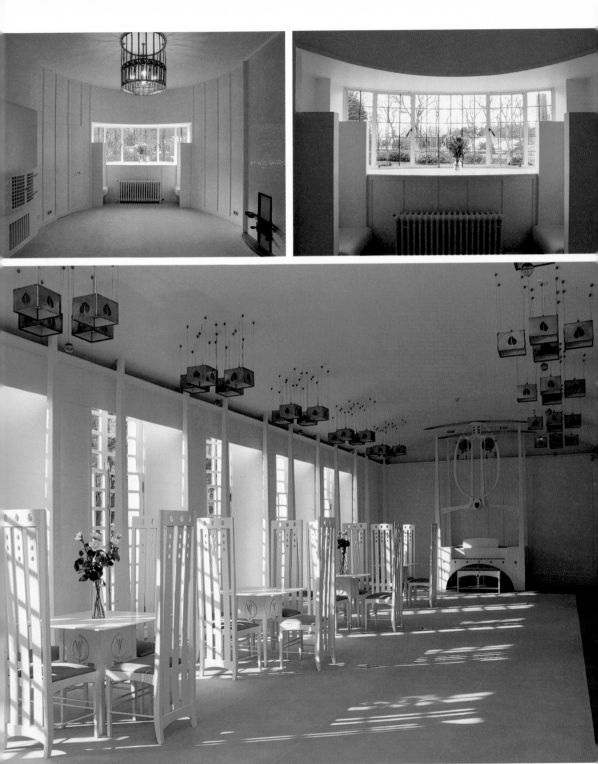

Chronology of Mackintosh's works

1868	Charles Rennie Mackintosh is born in Glasgow, UK.
1889	Taken on as a draftsman in the architectural studio of Honeyman & Keppie, in Glasgow, UK.
1890	Plan for an arts and science museum (study grant from the British institution) in the Beaux Arts style.
1892	Plan for a chapter house.
1894	Elements of the tower on the Glasgow Herald Building, by Honeyman & Keppie, UK.
	"Coles", watercolour for a student magazine at the Glasgow School of Art, UK.
1895	Features of the Royal Insurance Palace in Buchanan Street, Glasgow, by Honeyman & Keppie, UK.
	Designs for tombstones in the south of England and Scottish houses, UK.
	Martyr's Public School, Glasgow, UK.
1896	Elements of the Queen Margaret School and the Glasgow University School of Medicine, by Honeyman & Keppie, UK.
	Furniture exhibited in the Arts & Crafts society exhibition, in London, UK.
1897	Tea room for Cranston in Buchanan Street, Glasgow, UK (not conserved).
1897–1909	Glasgow School of Art, in Renfrew Street, Glasgow, UK.
1898–1899	Queen's Cross Church, in Garscube Road, Glasgow, UK.
1900	Offices for the "Daily Record" in Renfield Lane, Glasgow, UK.
1901	Competition entry for a House for an Art Lover, organized by a German magazine.
	Plan for a house for the Glasgow international exhibition.
	Windyhill, in Kilmacolm, UK.
1902–1903	The Hill House, in Helensburg, UK.
1903	Plan for the Liverpool Anglican Cathedral, UK.
	Willow Tea Rooms for Cranston in Sauchiehall Street, Glasgow, UK.
1904	Scotland Street School, Glasgow, UK.

	Organ case and altar for the church at Bridge of Allan, UK.
1905–1907	Tea room for Cranston in Argyle Street, Glasgow, UK.
1907	Alteration of the house "The Moss", in Dumgoyne, UK.
	Country house in Auchinbothie, UK.
1907–1908	Interior fitting-out of Hous' Hill, Nitshill, UK (not conserved).
	Wing of the library at the Glasgow School of Art, UK.
1907–1911	Tea room for Cranston in England Street, Glasgow, UK.
1908	Entrance for the Women's Arts Club, Glasgow, UK.
1911	Silver dinner service, tablecloths, menus and advertisement for "The White Cockade", Glasgow international exhibition, UK.
1916	Interior fitting-out of the house of Mr. Bassett-Lowke, Northampton, UK.
	"The Dugout" tea room for Cranston, Glasgow, UK.
1920	Plan for three studios for artists in Glebe Place, Chelsea, London, UK.
1927	Moves to France, where he paints in oils and watercolours.
1928	Charles Rennie Mackintosh dies in London, UK.
1933	Retrospective exhibition, Glasgow, UK.
1968	Centenary exhibition, Glasgow, UK.

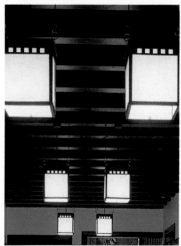

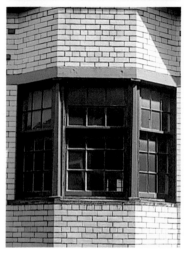
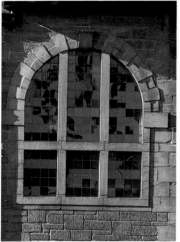
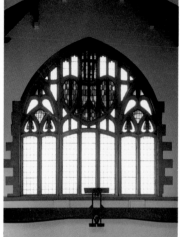